Angela Porter's
Zen Doodle
Animal Tangles

Racehorse Publishing books may be purchased in bulk at special discounts for sales promotion, corporate gifts, fund-raising, or educational purposes. Special editions can also be created to specifications. For details, contact the Special Sales Department, Skyhorse Publishing, 307 West 36th Street, 11th Floor, New York, NY 10018 or info@skyhorsepublishing.com.

Racehorse Publishing™ is a pending trademark of Skyhorse Publishing, Inc.®, a Delaware corporation.

Visit our website at www.skyhorsepublishing.com.

10 9 8 7 6 5 4 3 2

Cover design by Brian Peterson
Cover artwork by Angela Porter

Print ISBN: 978-1-944686-03-1

Printed in the United States of America

Angela Porter's Zen Doodle Animal Tangles

New York Times Bestselling Artists' Adult Coloring Books

ANGELA PORTER

Racehorse Publishing

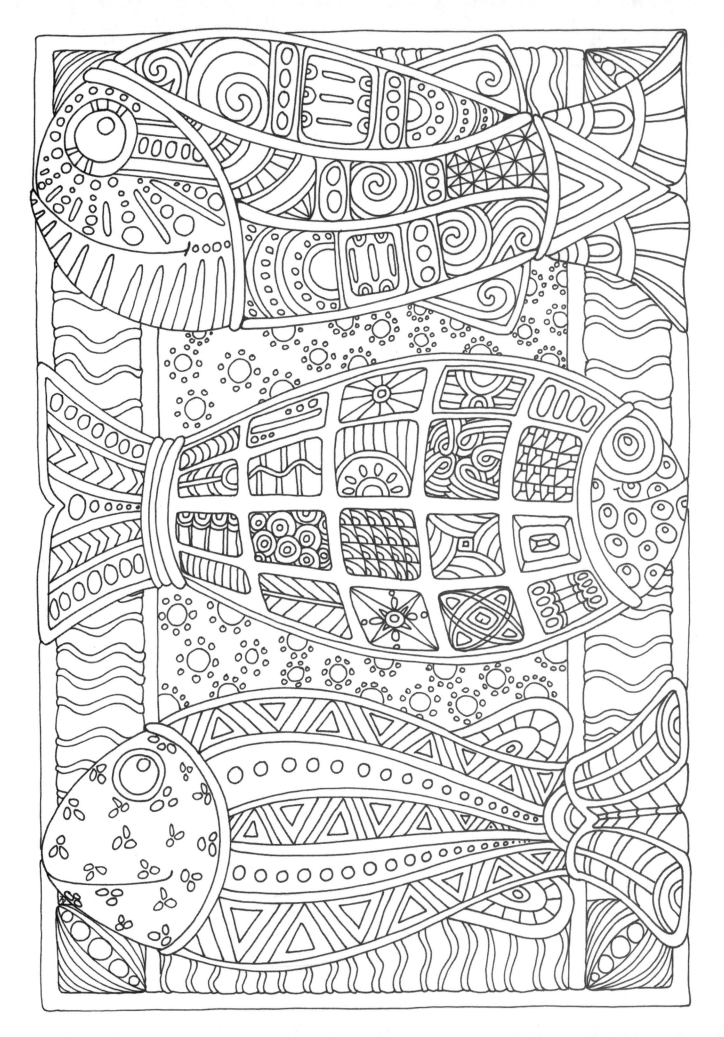

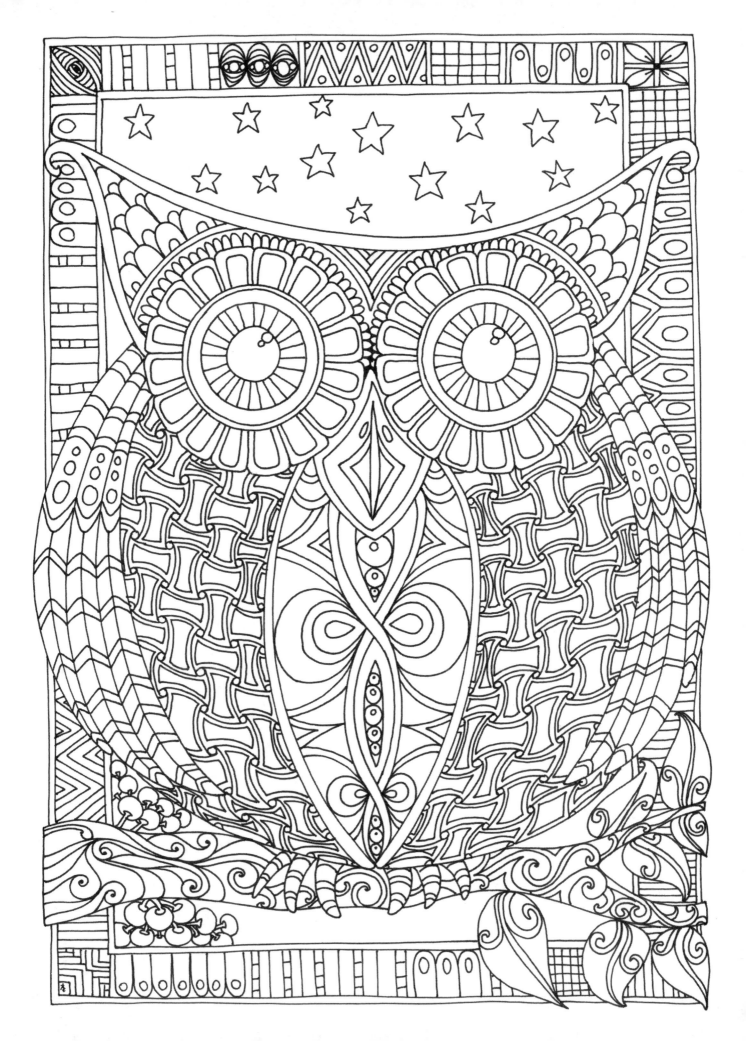

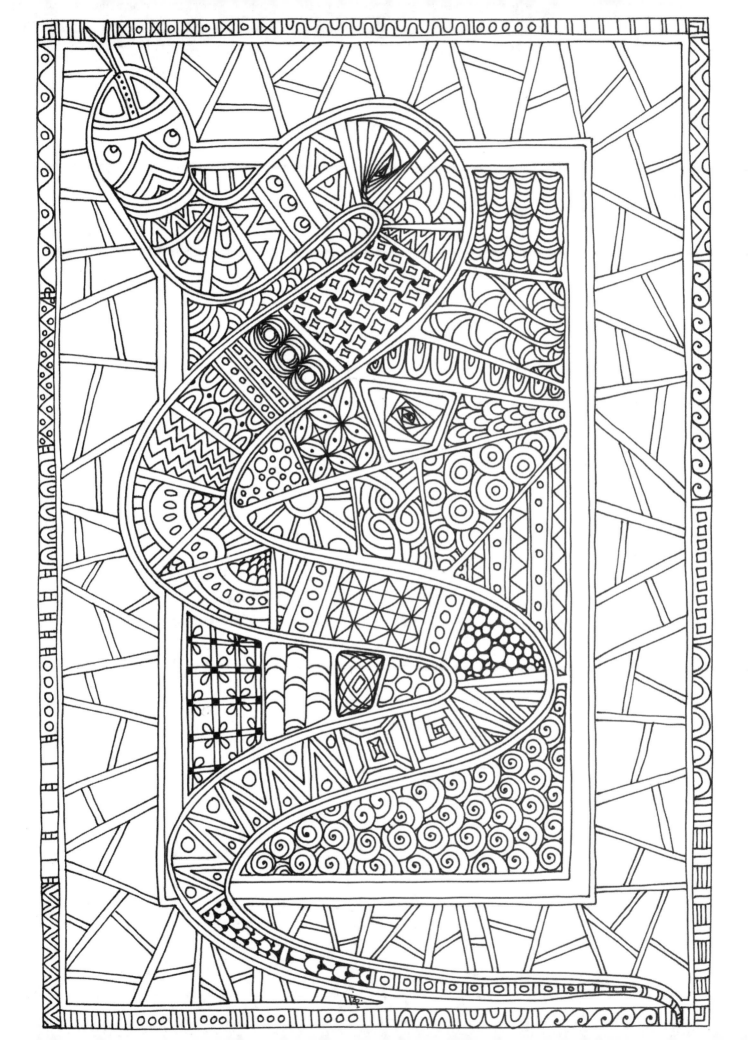

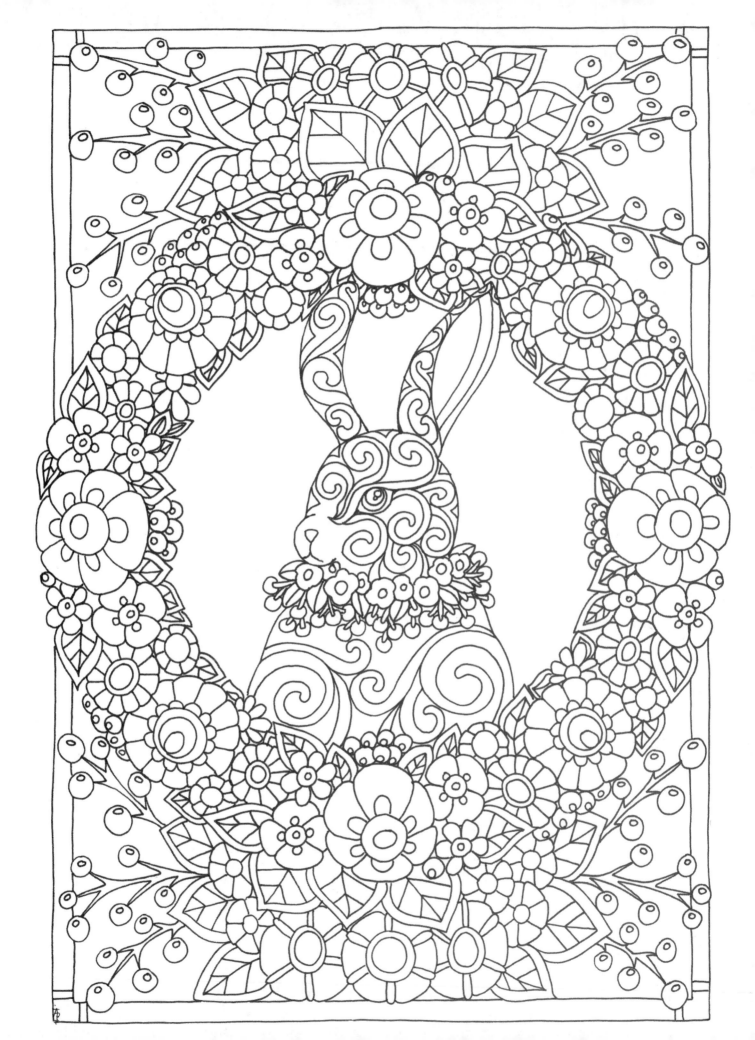

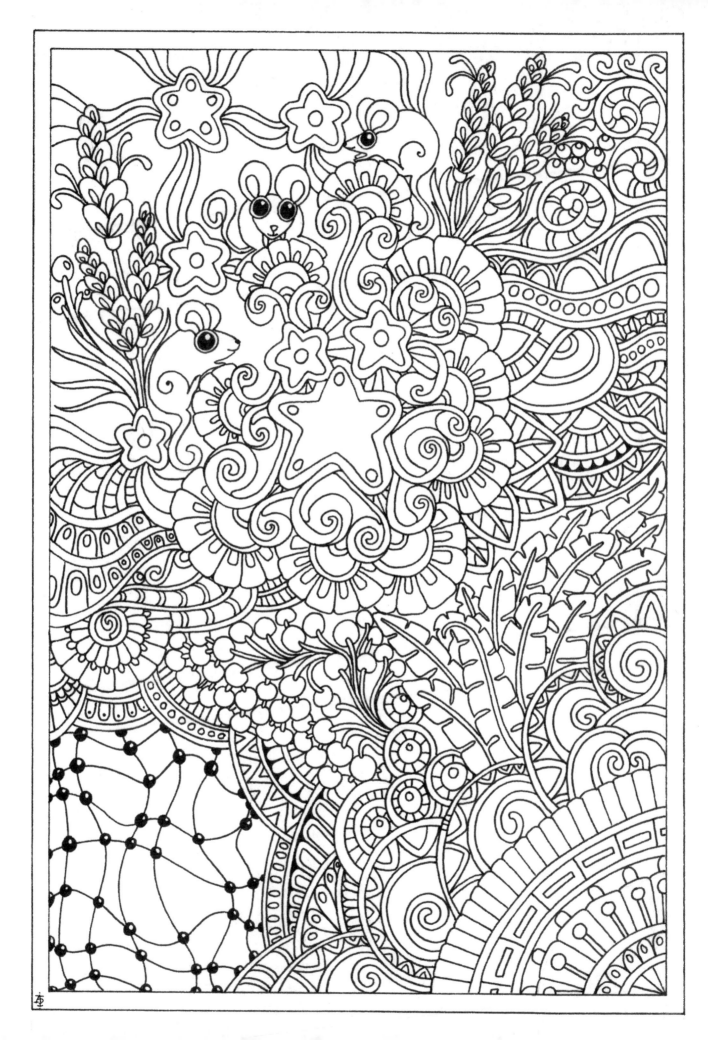

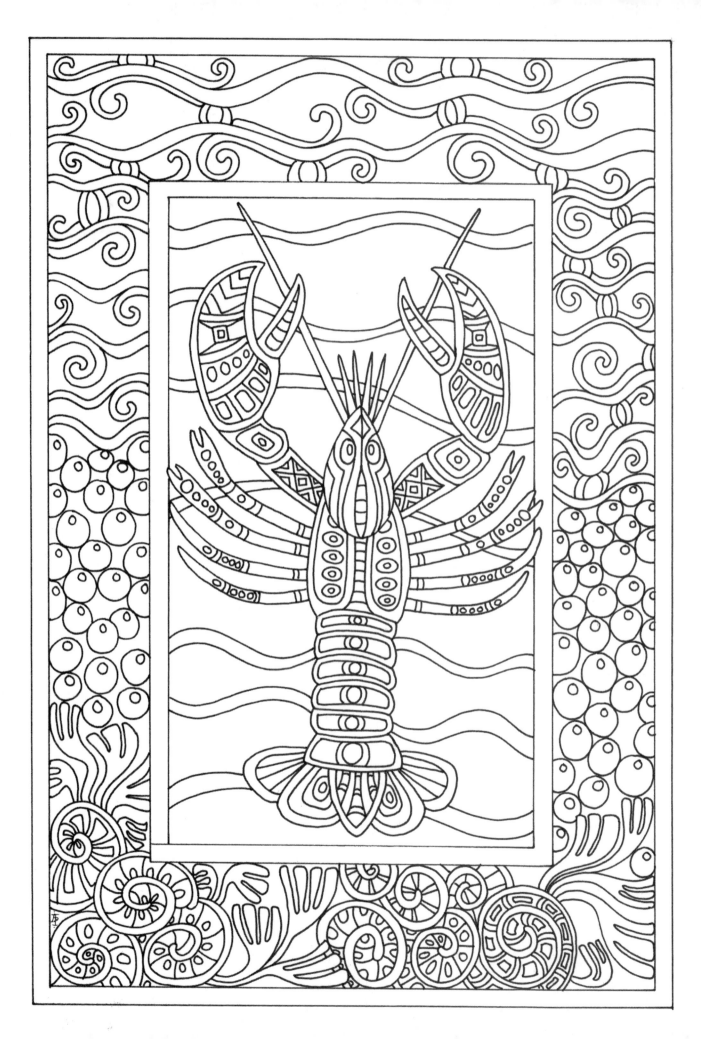

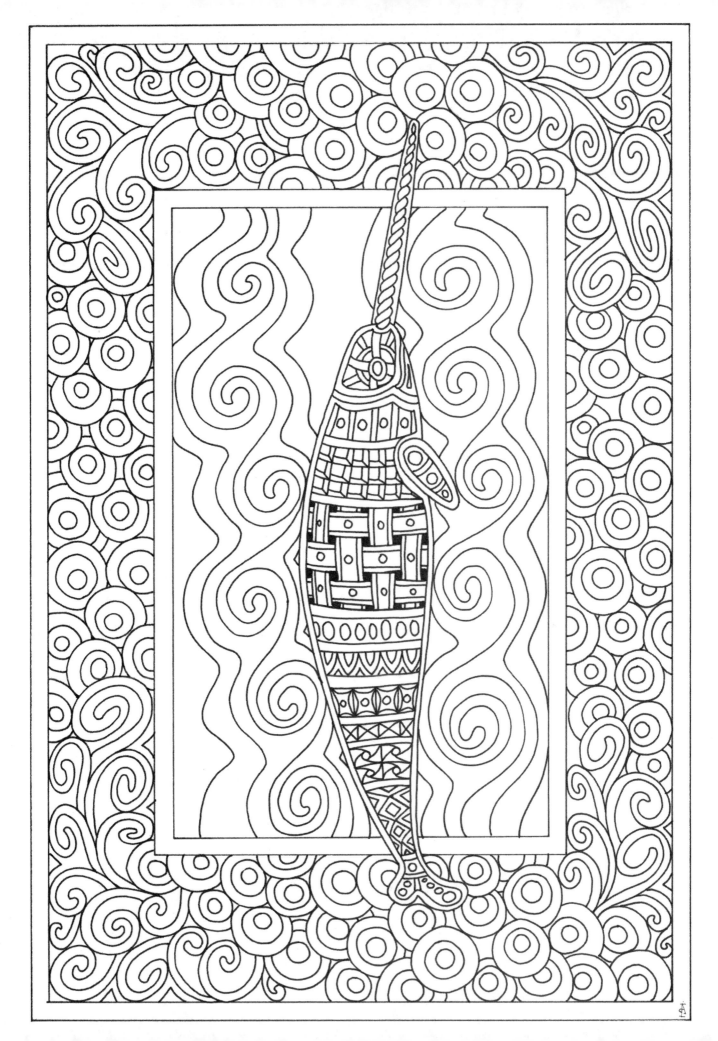

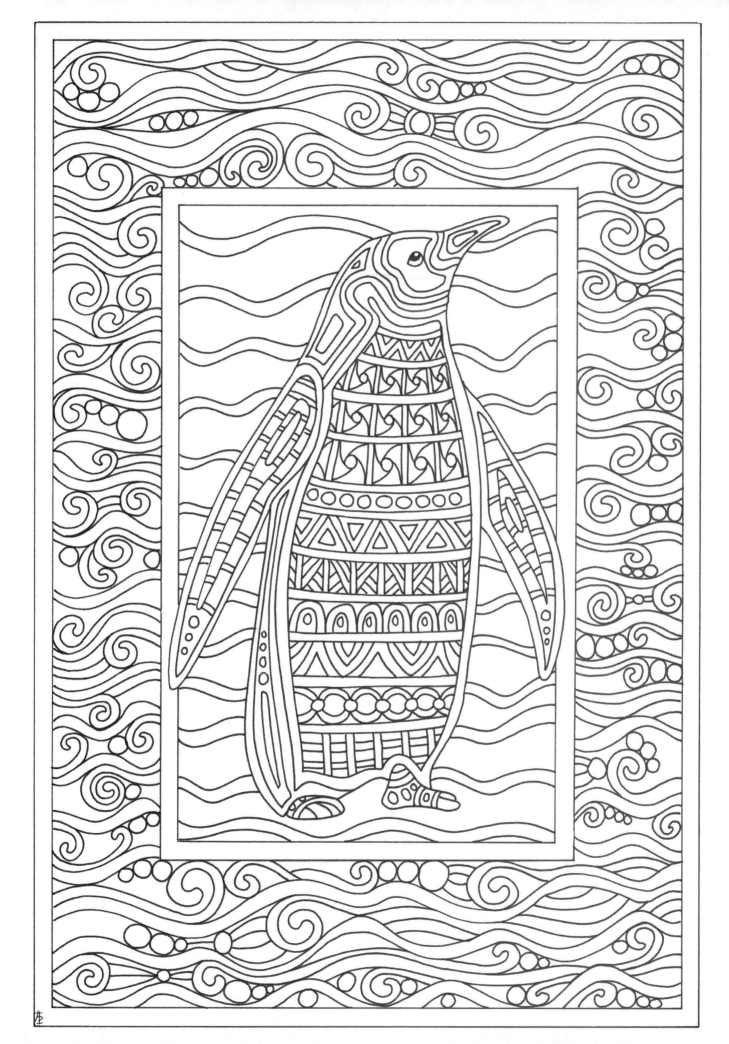

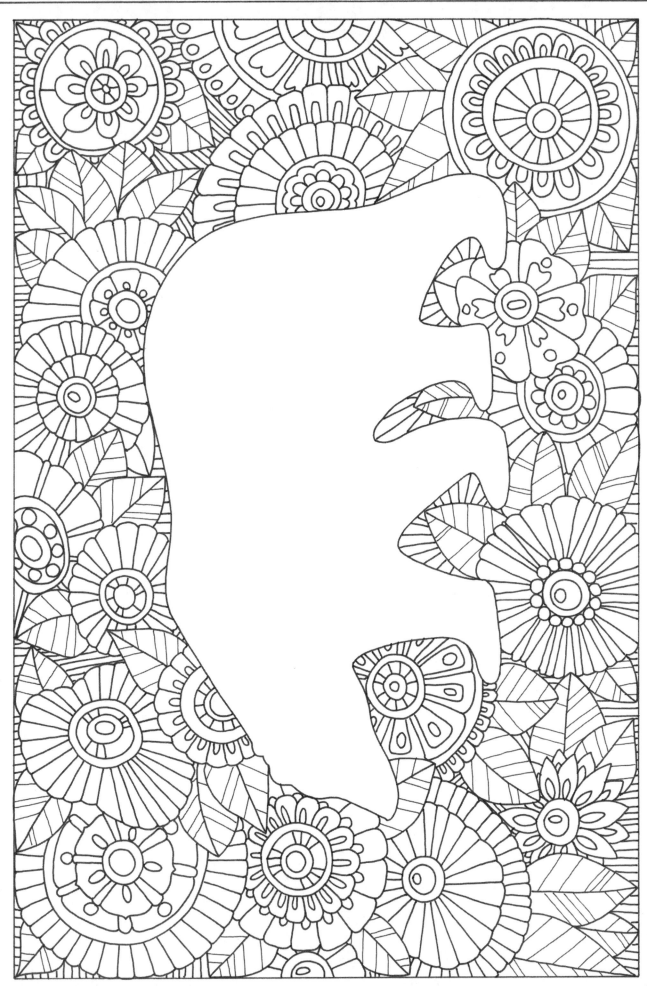

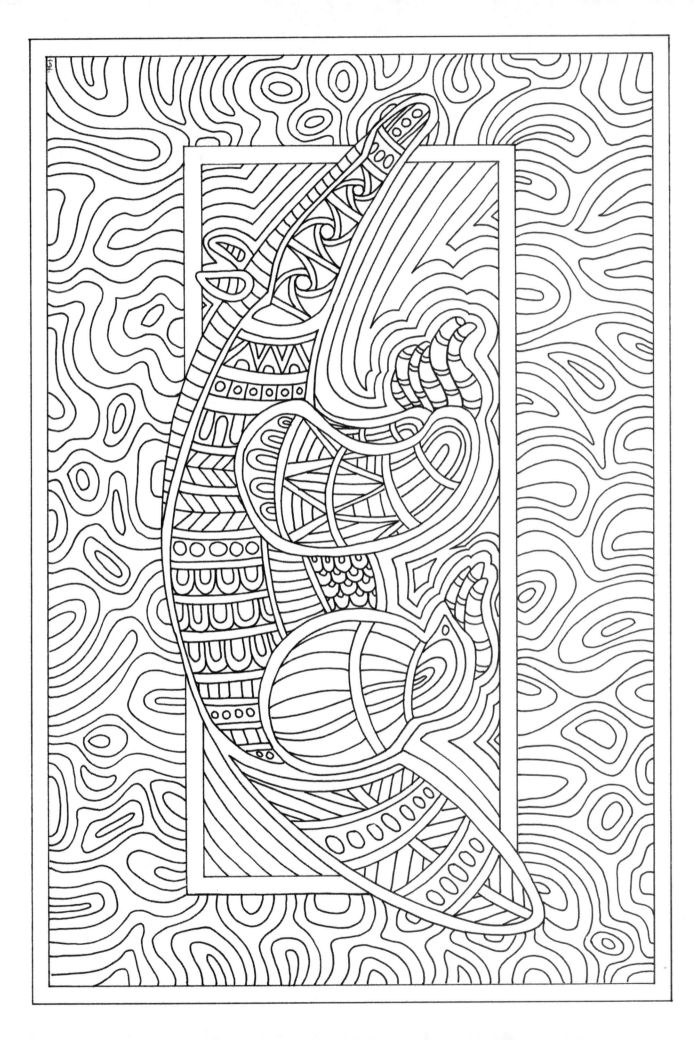

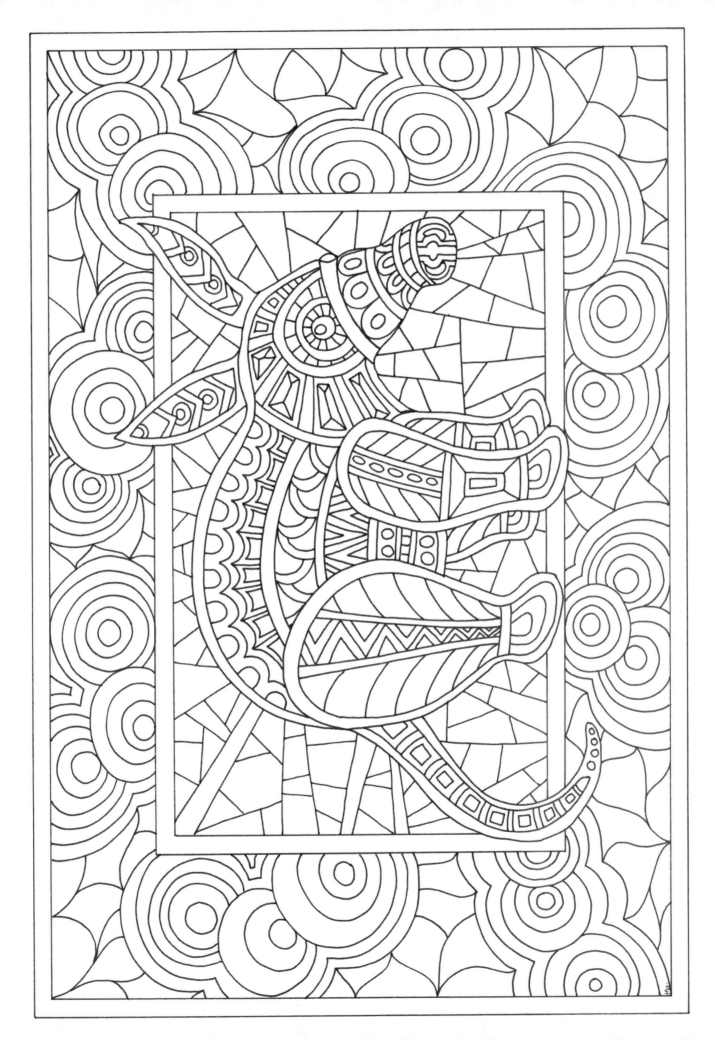

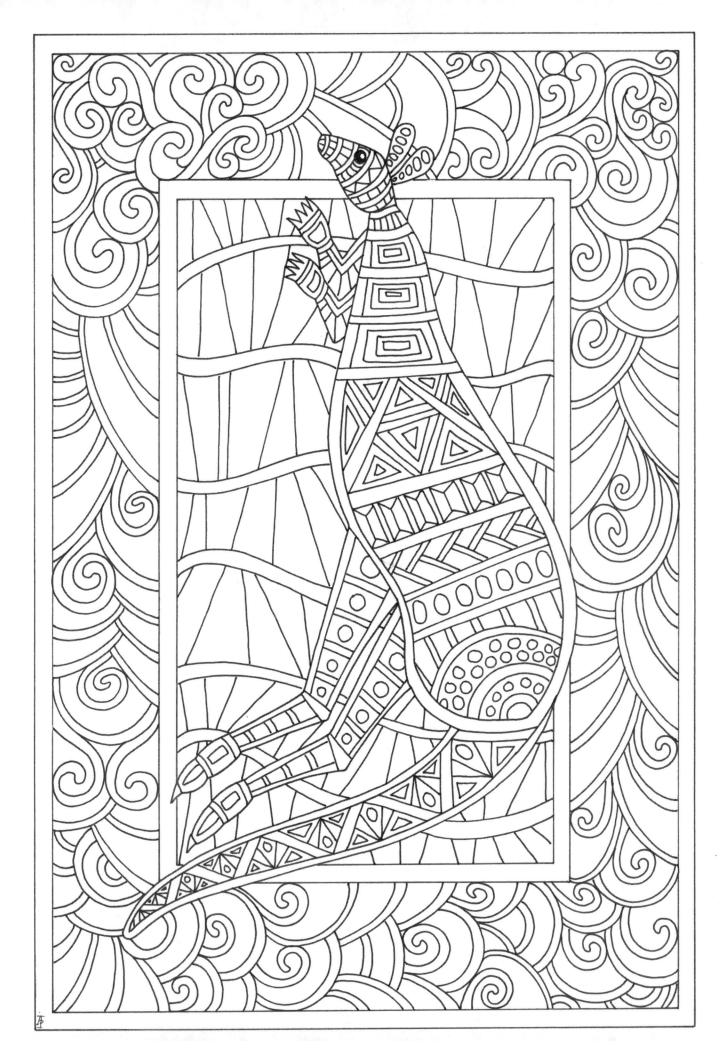

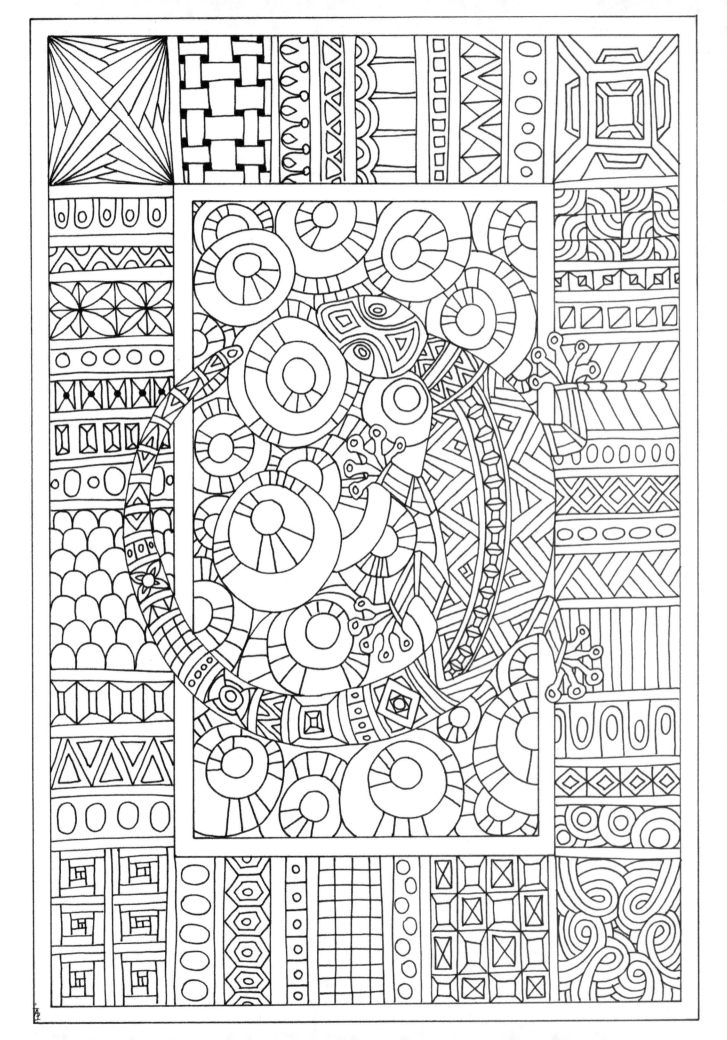

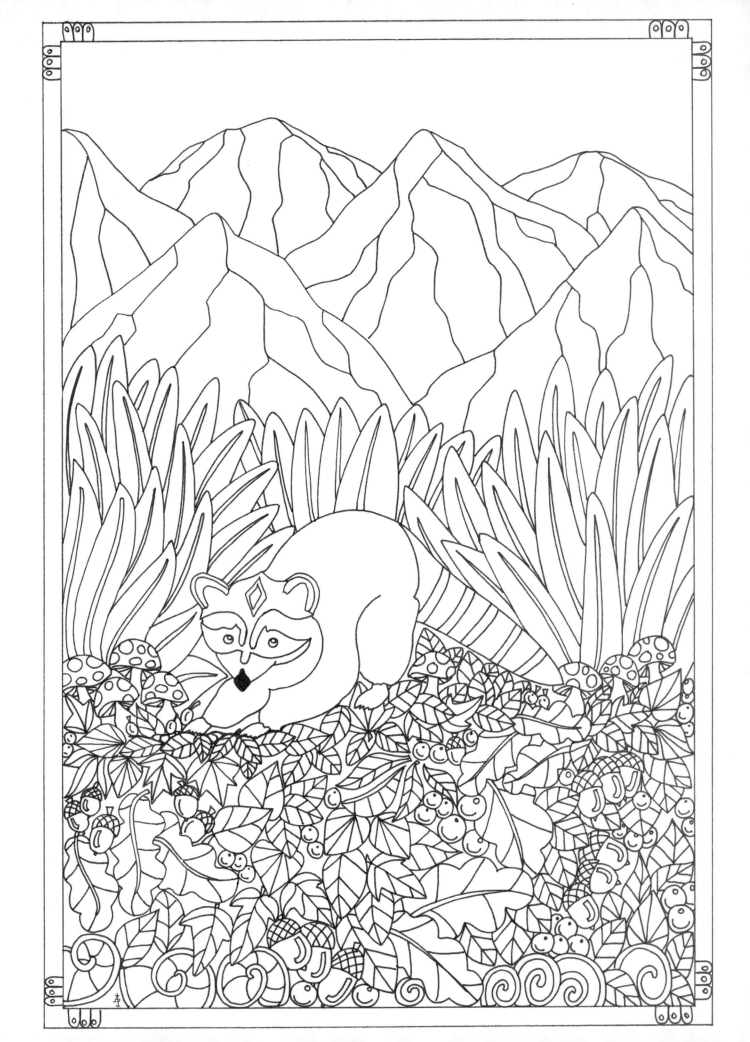

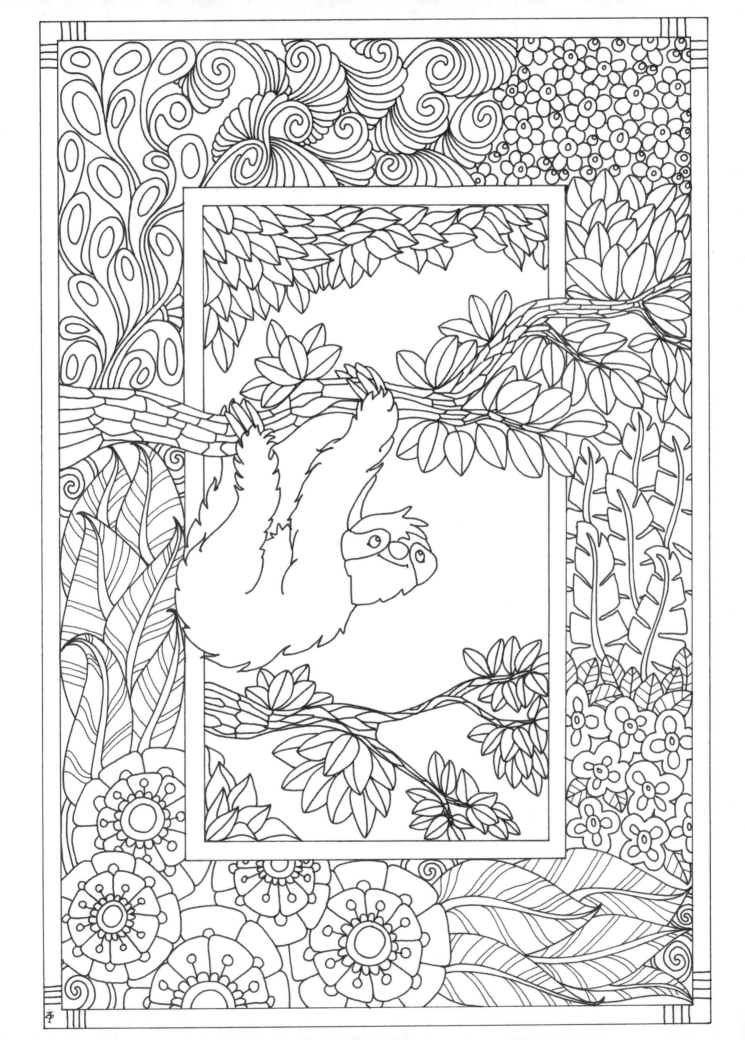

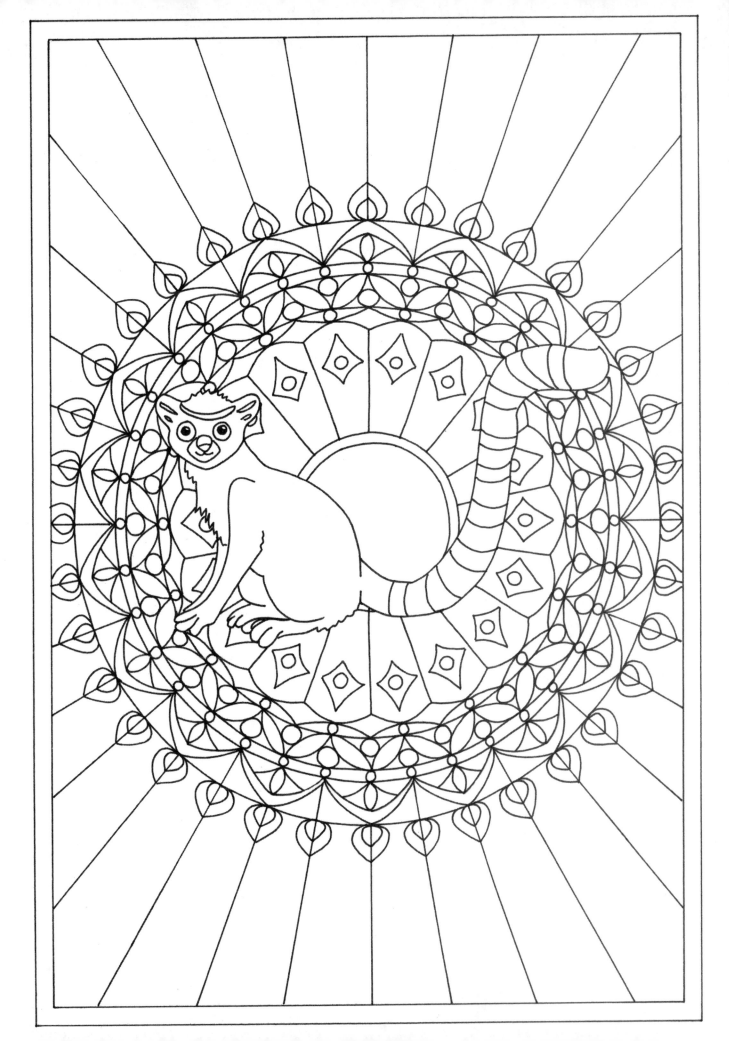

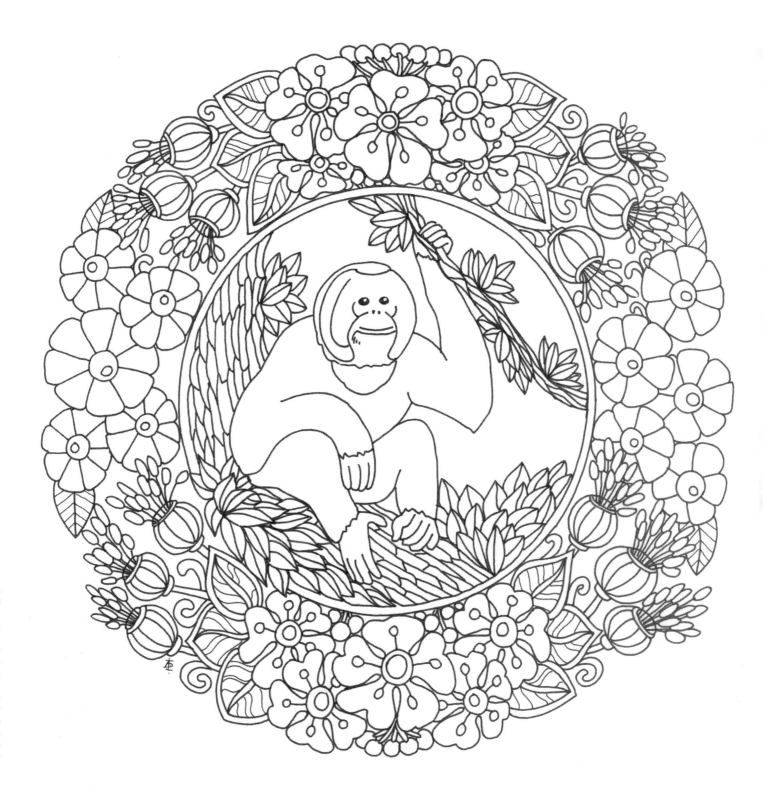

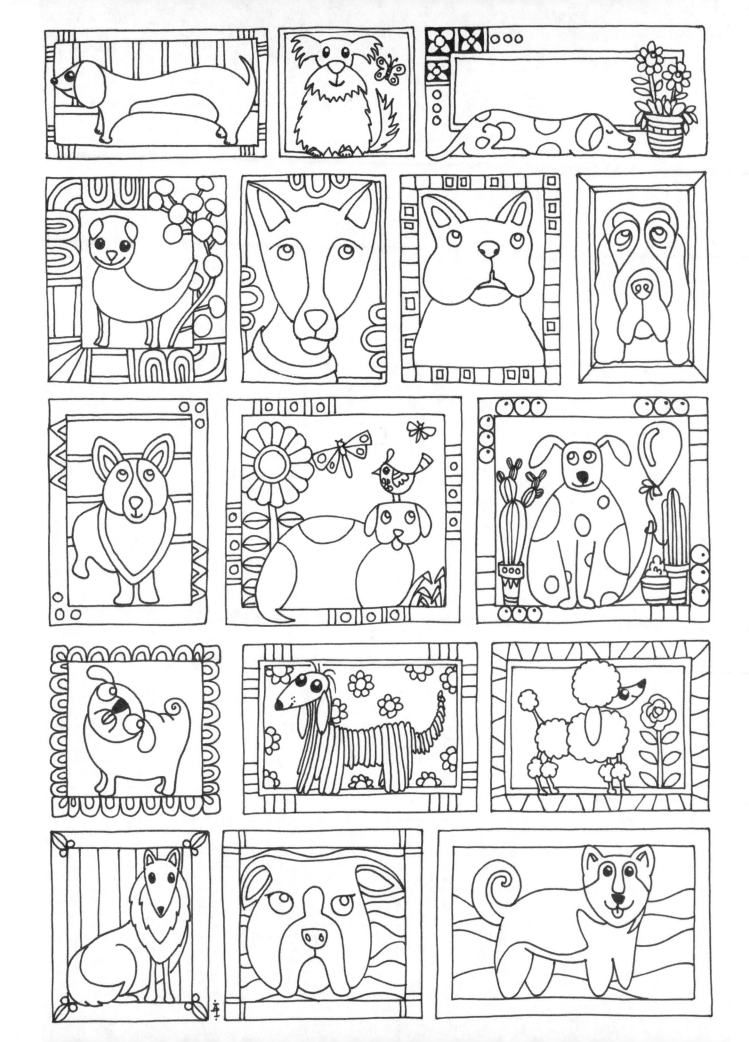

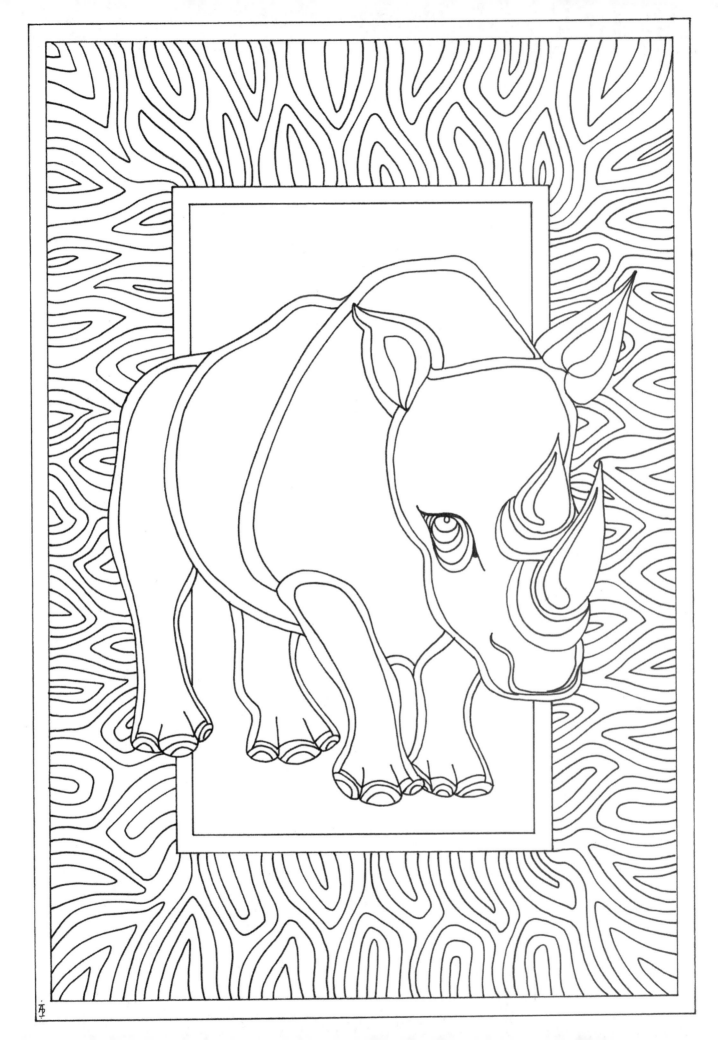

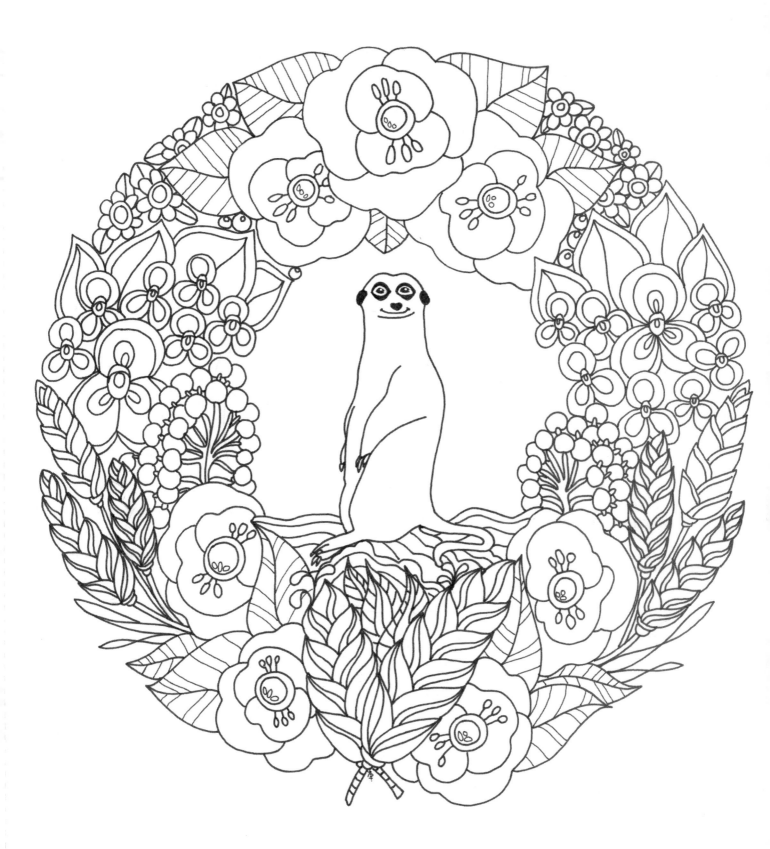

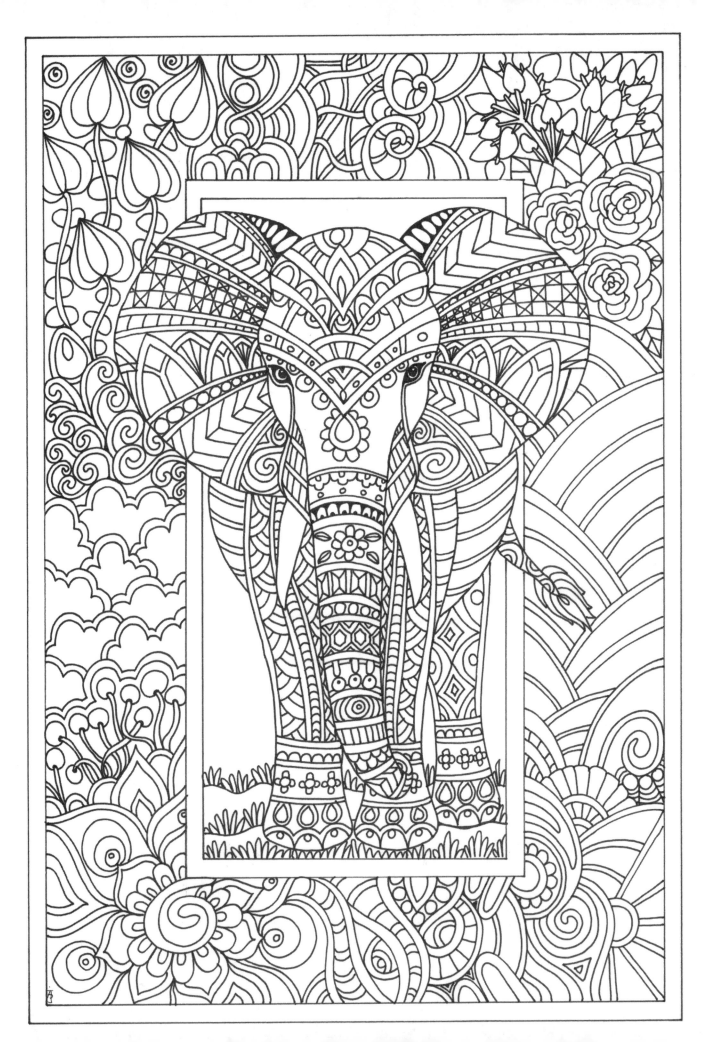

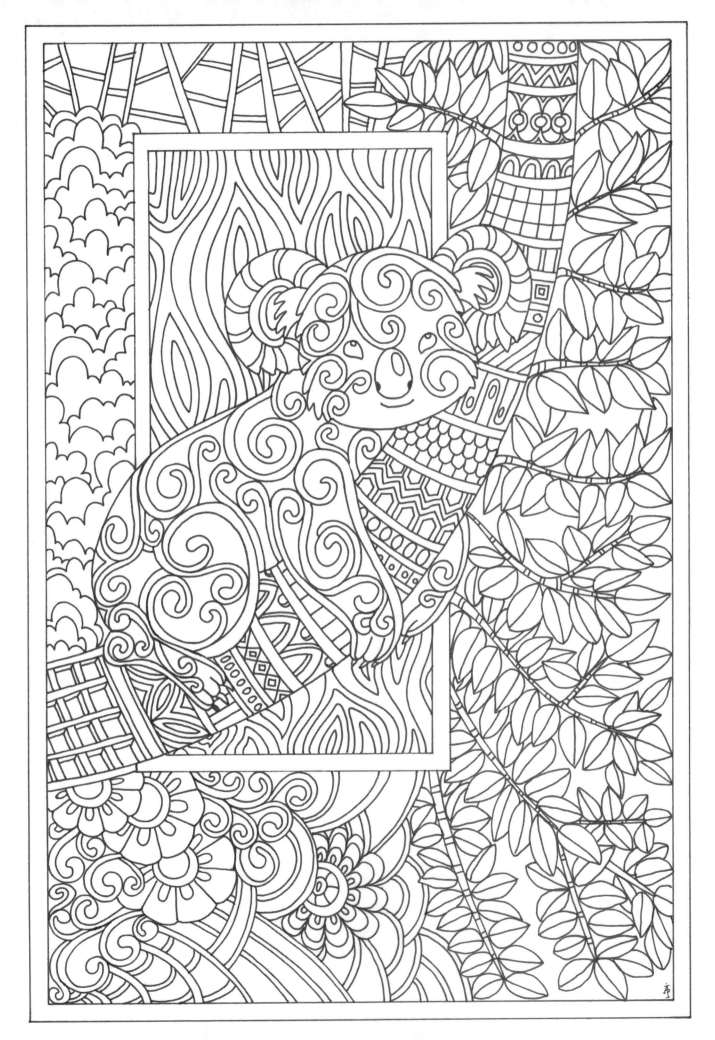

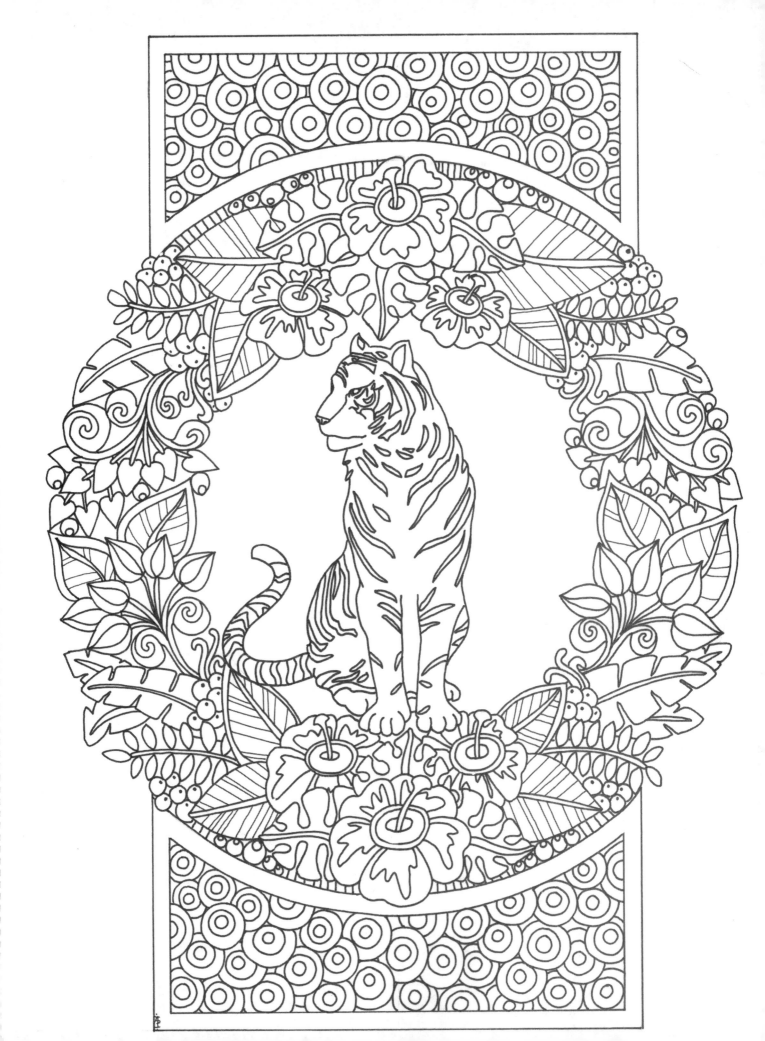

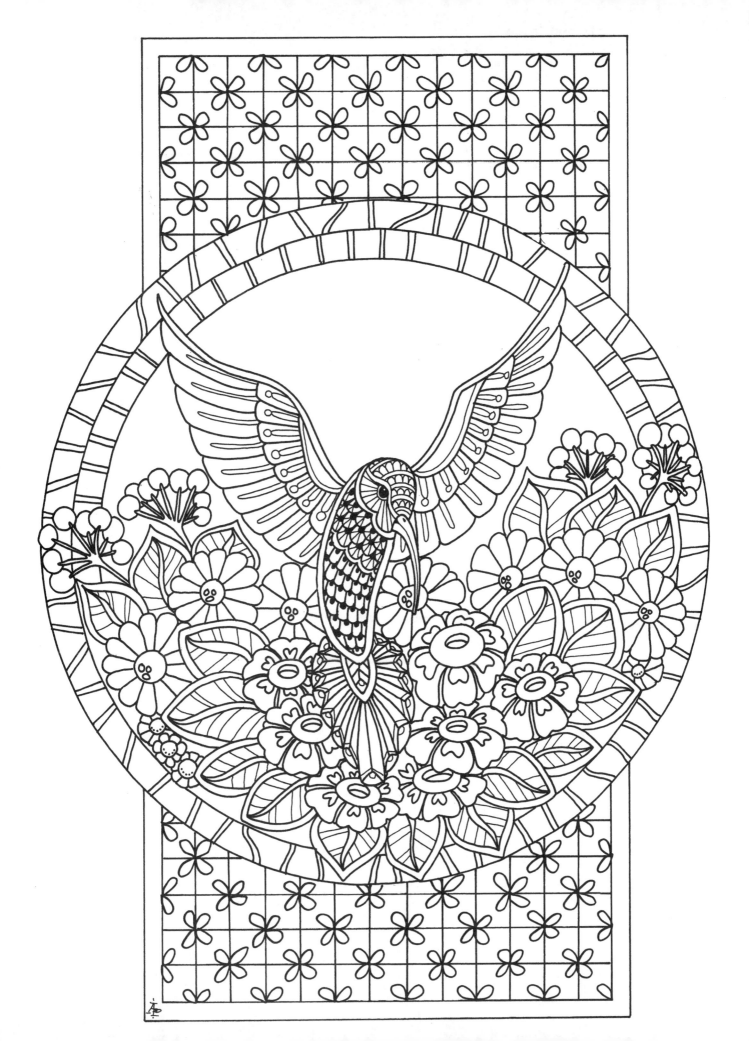

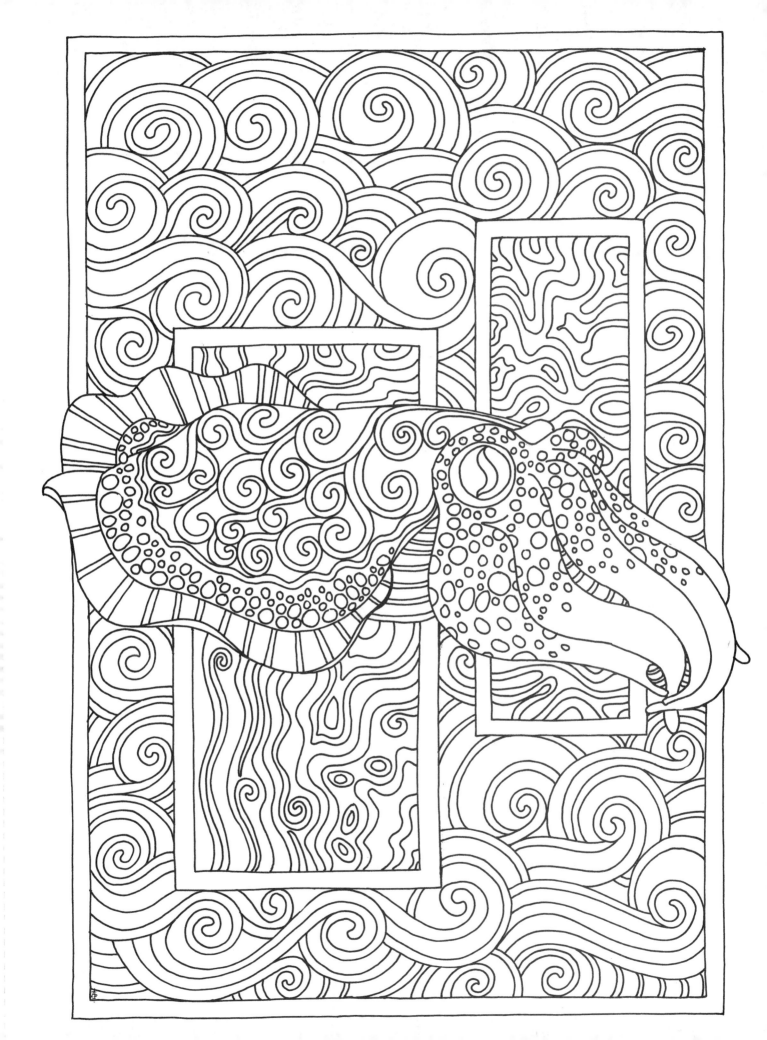

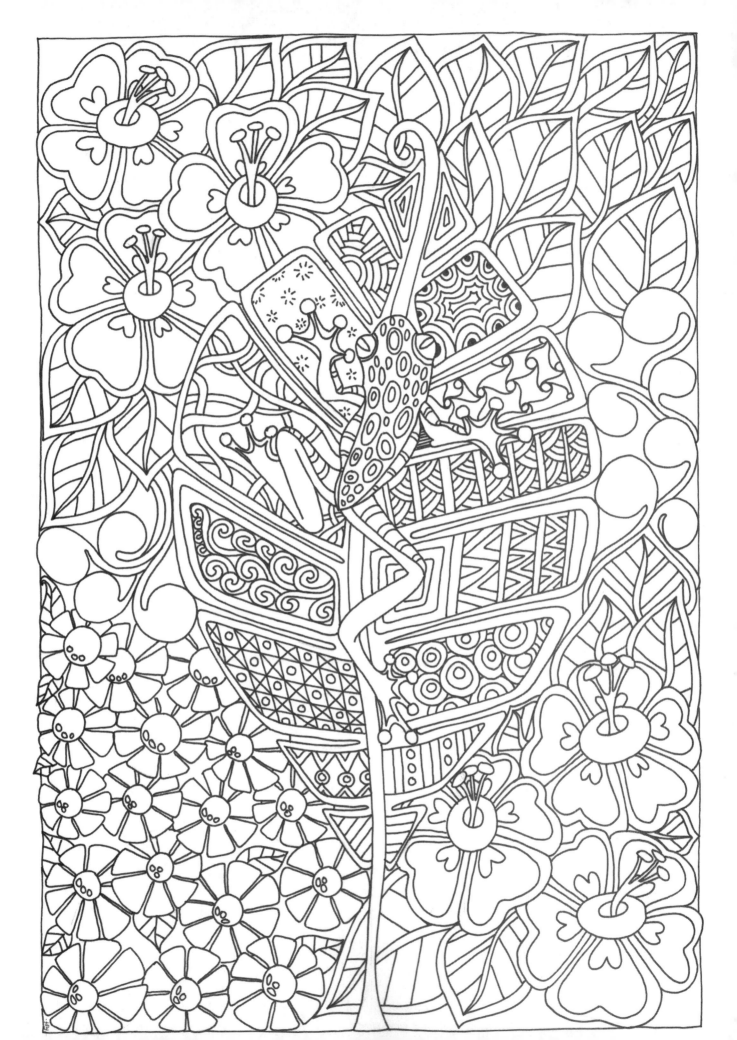

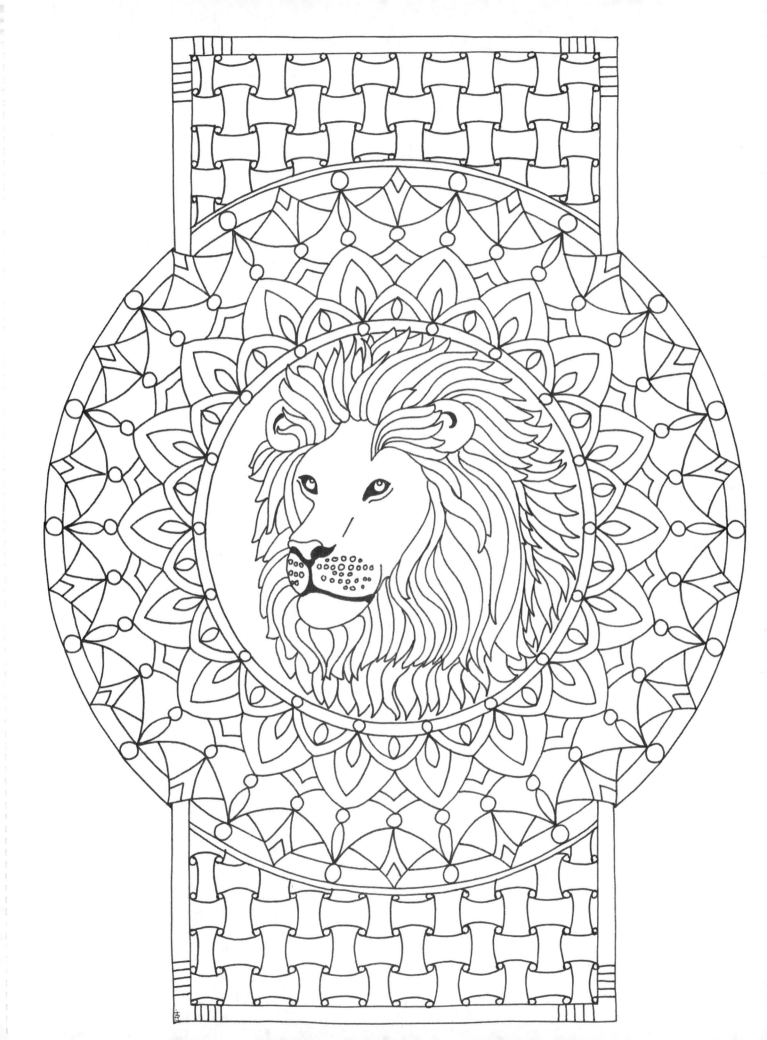

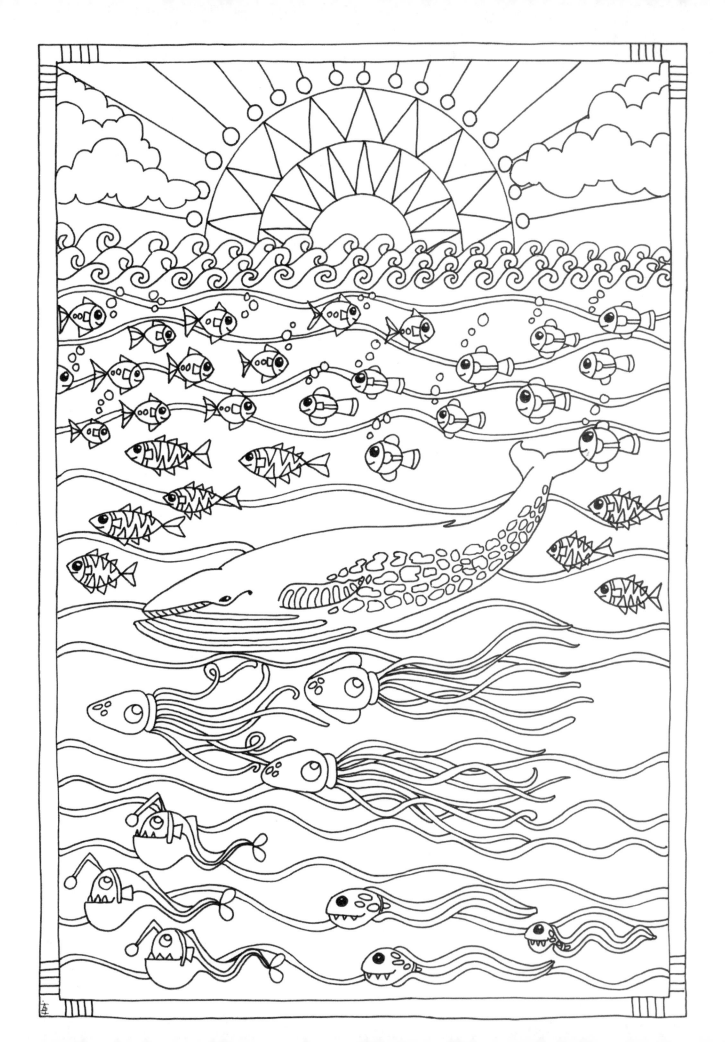

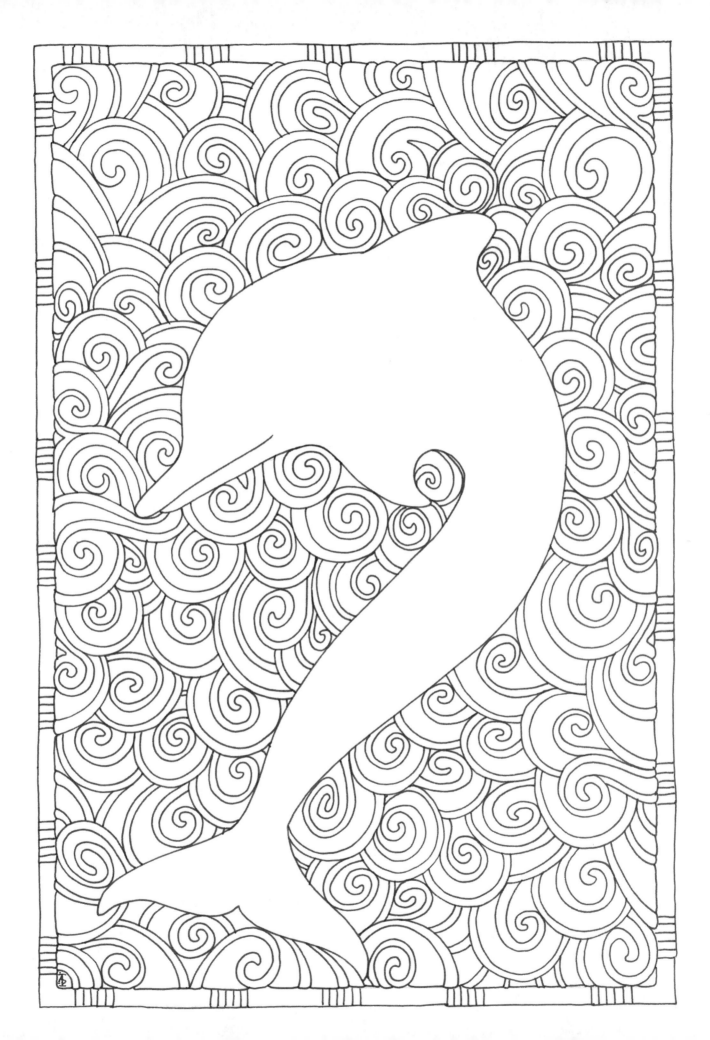

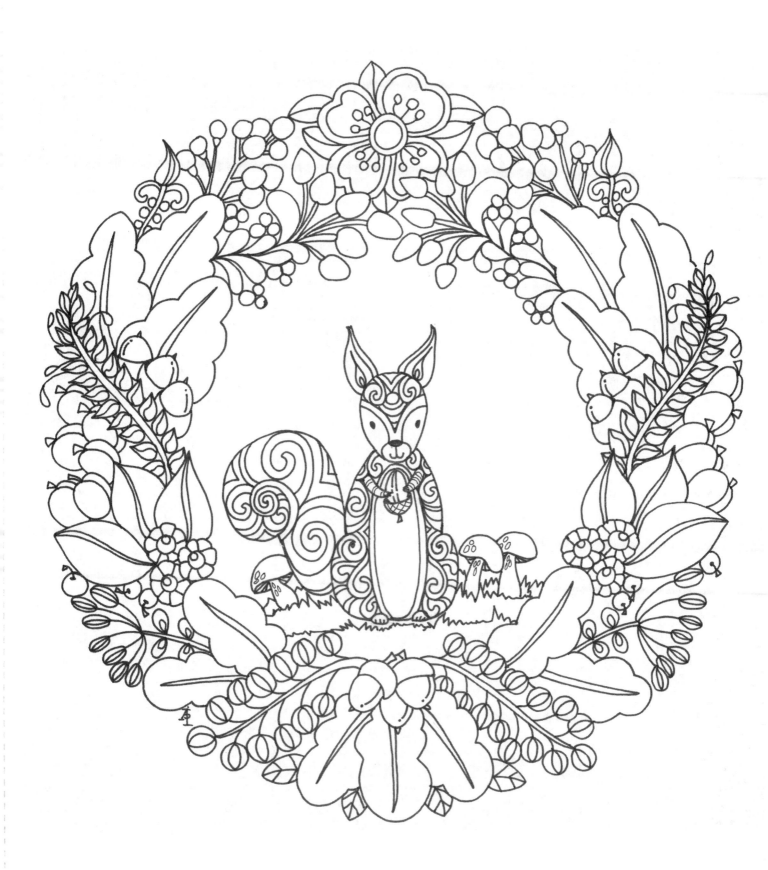

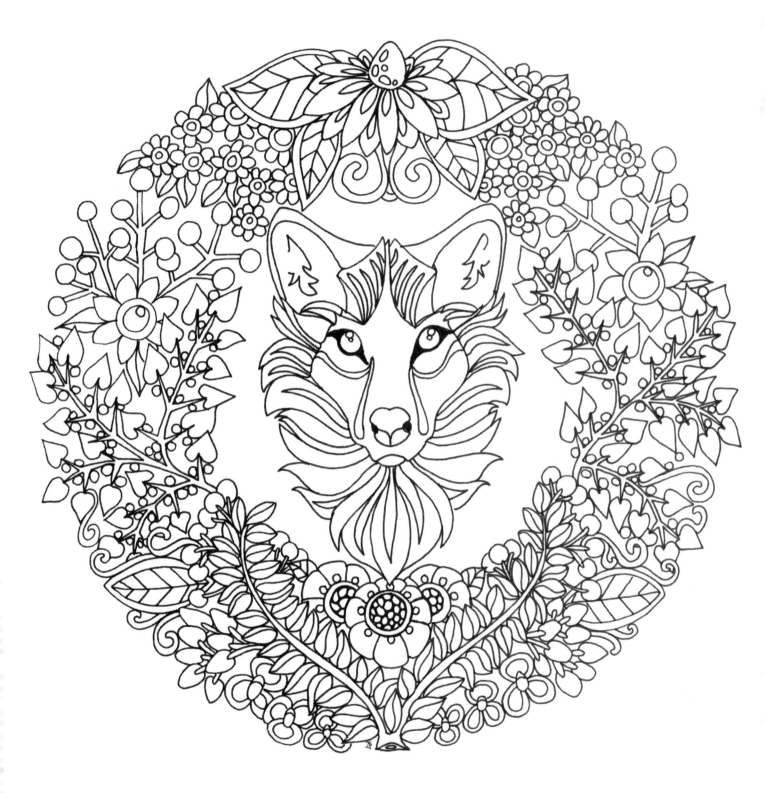

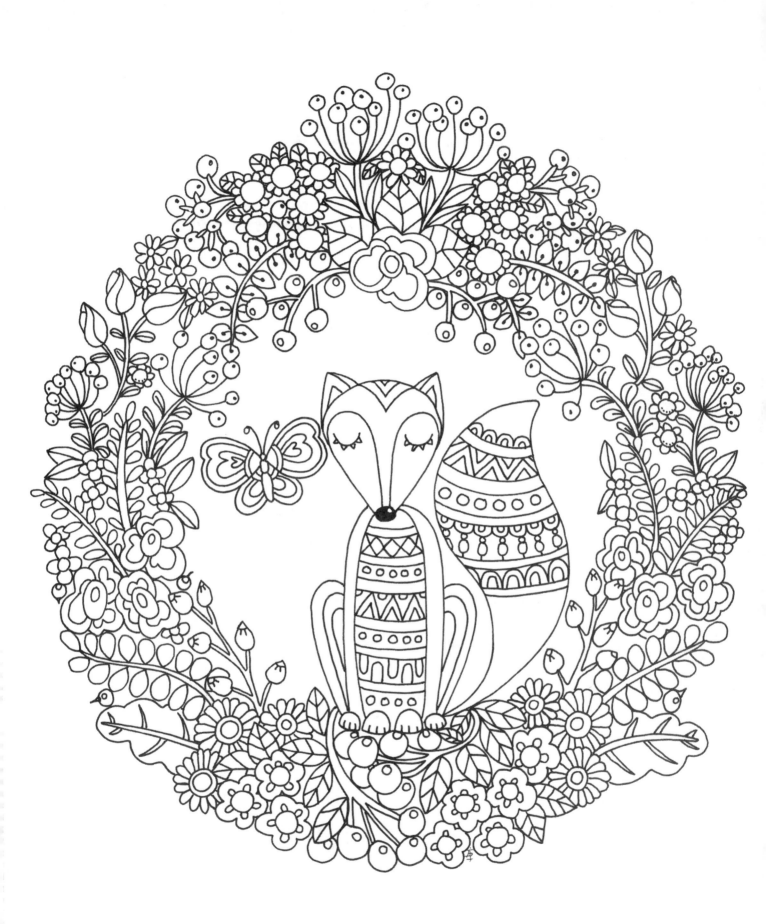

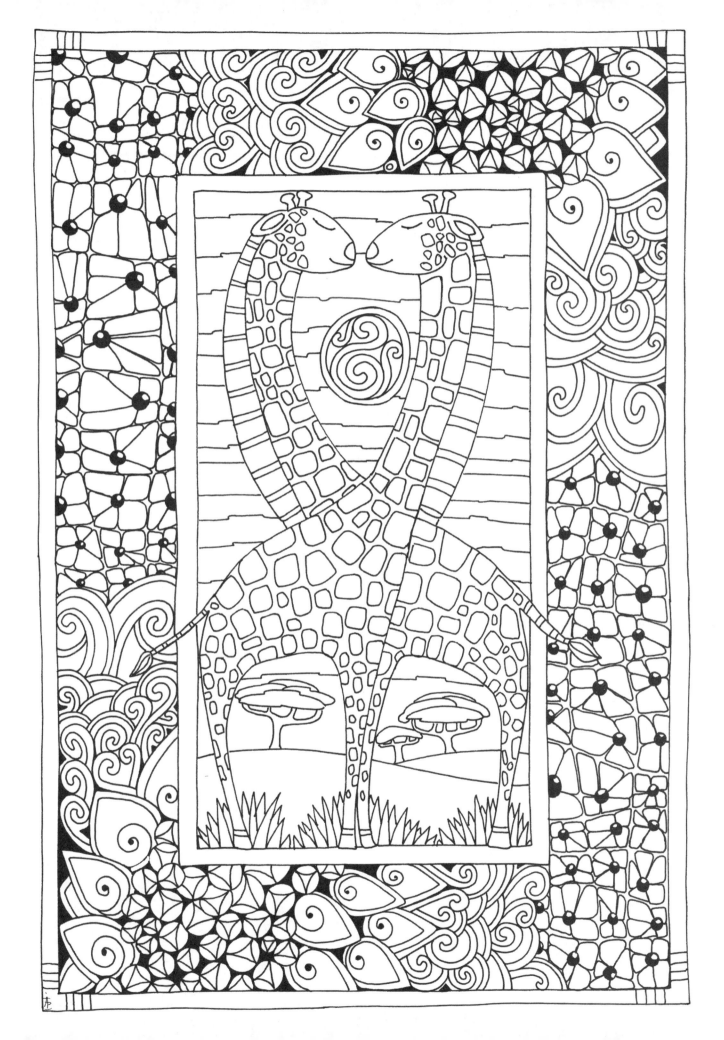

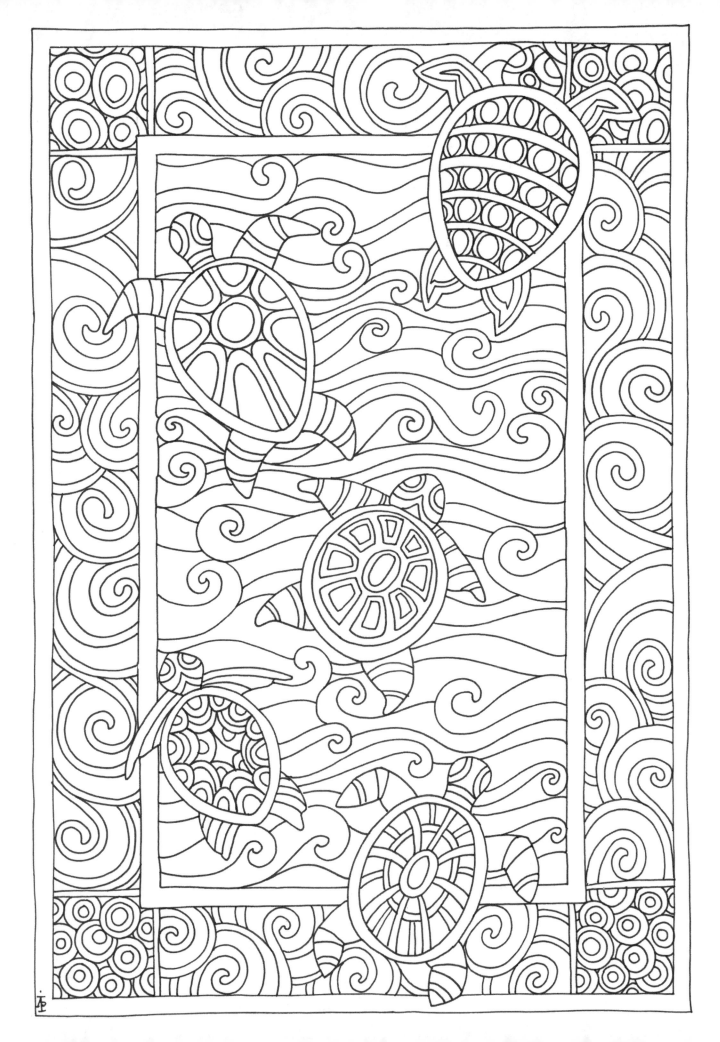

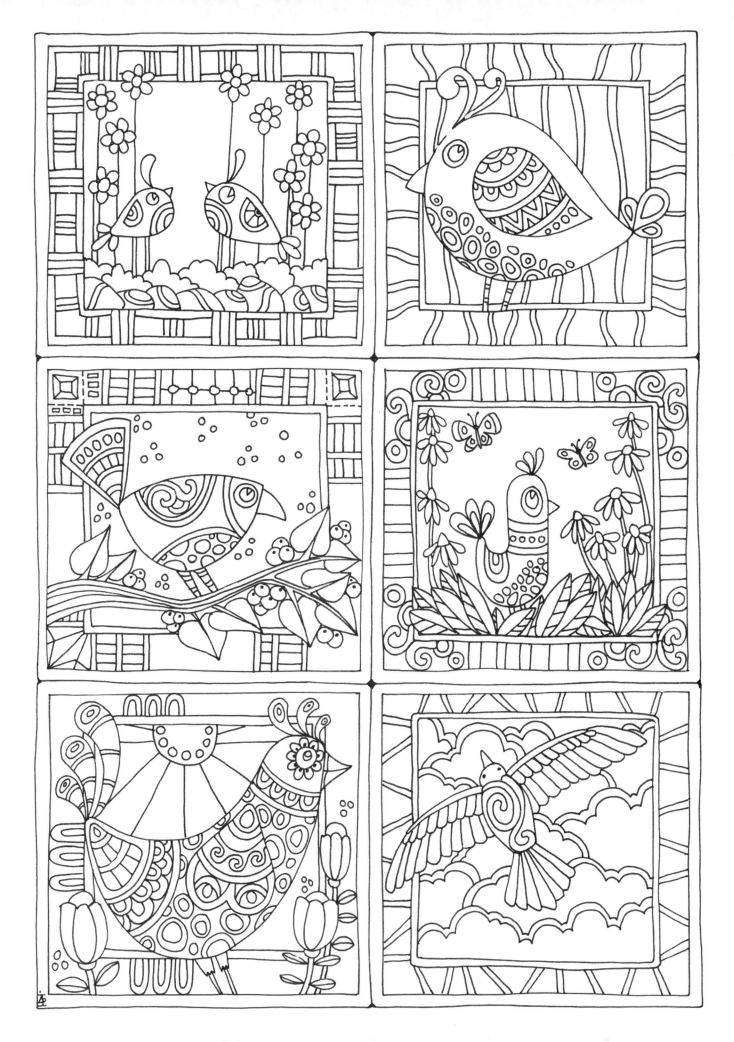

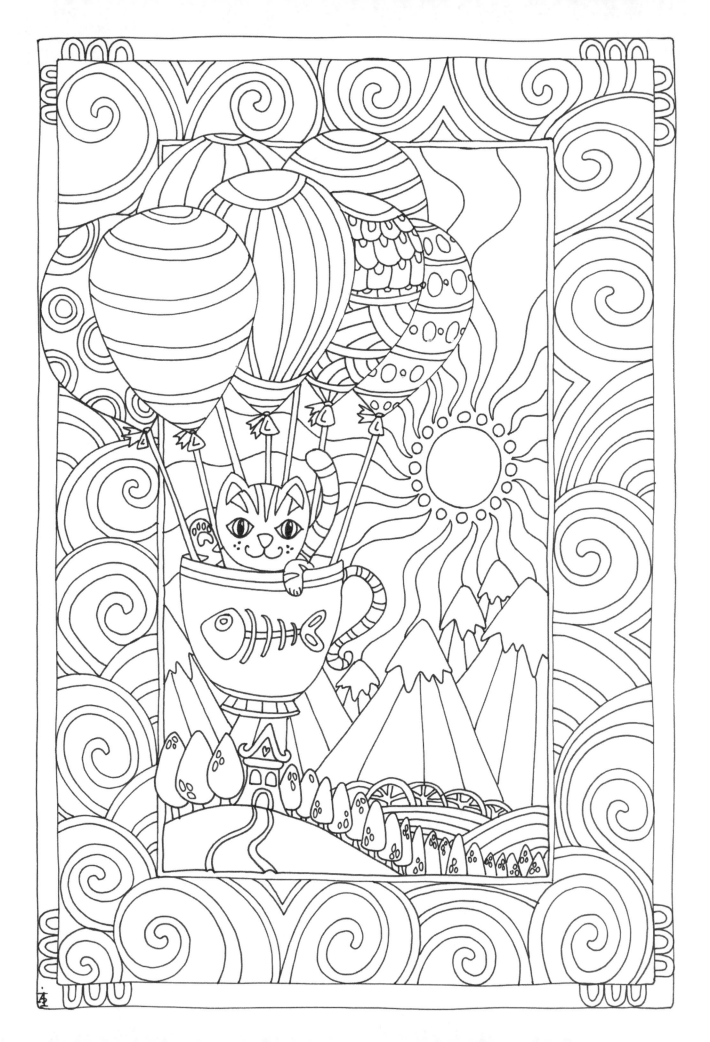

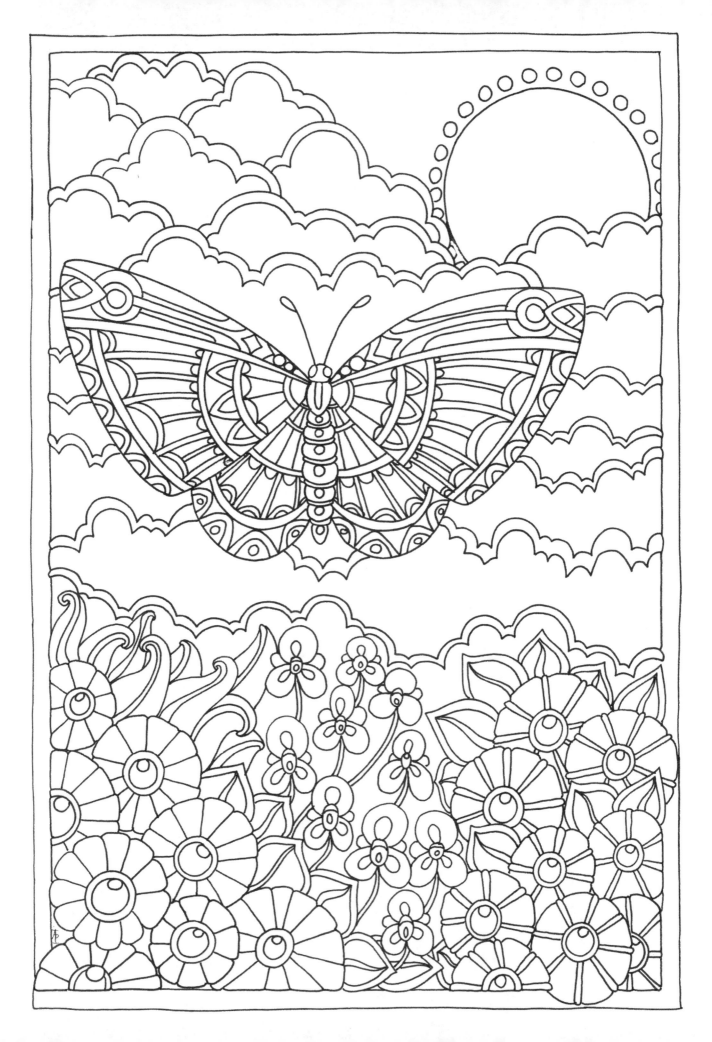

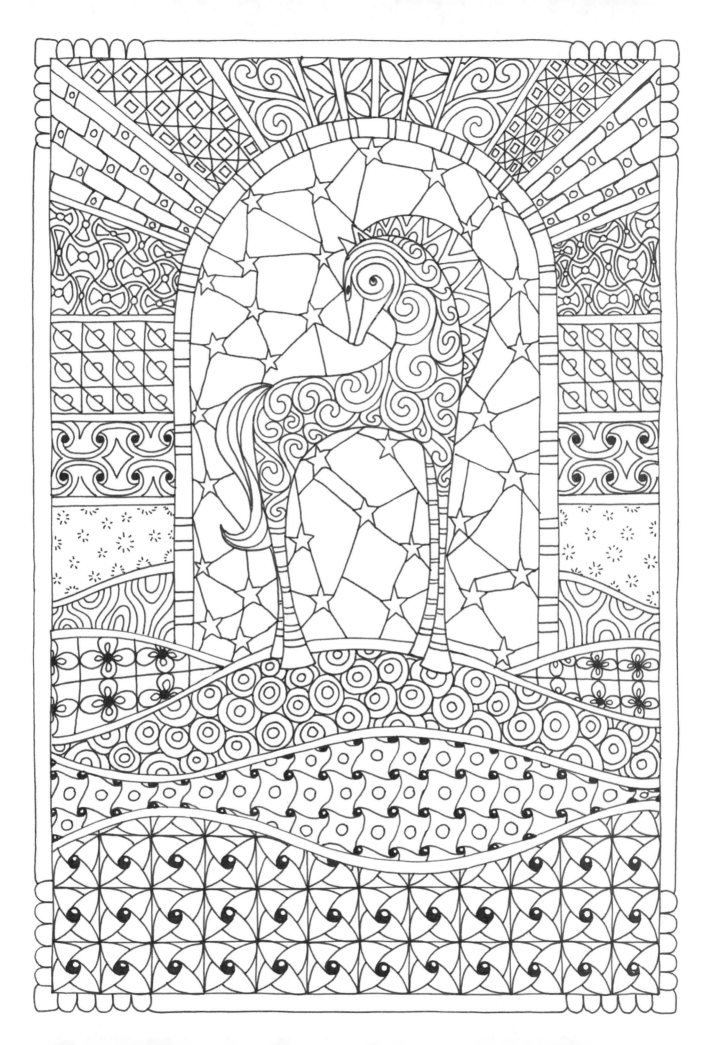

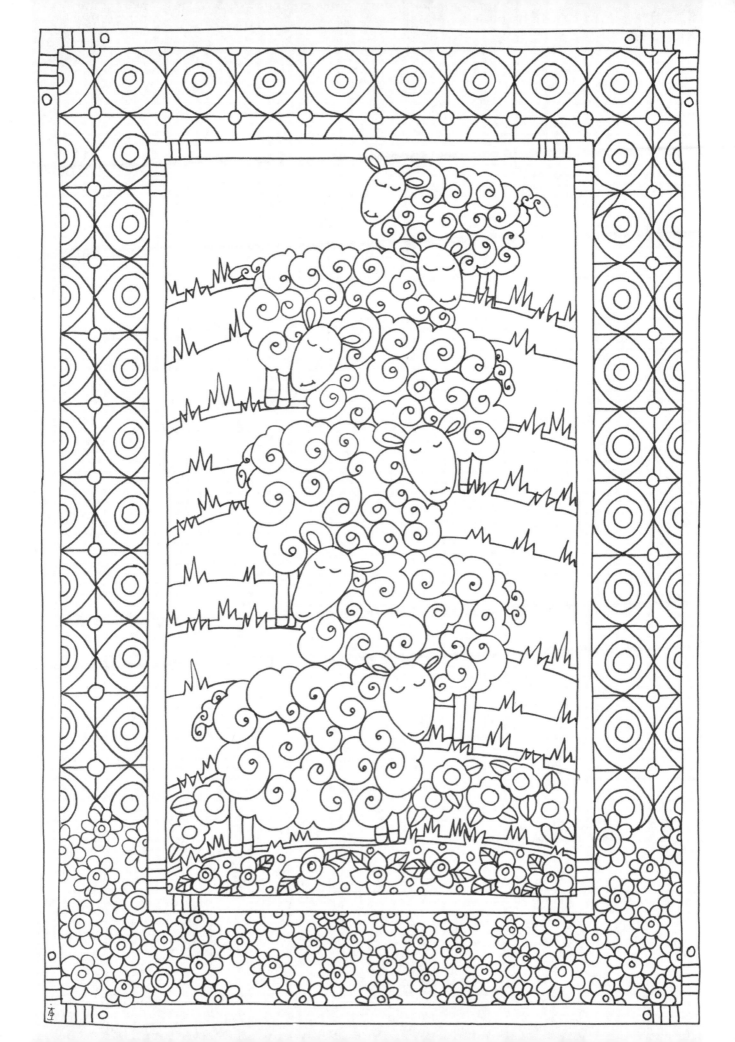

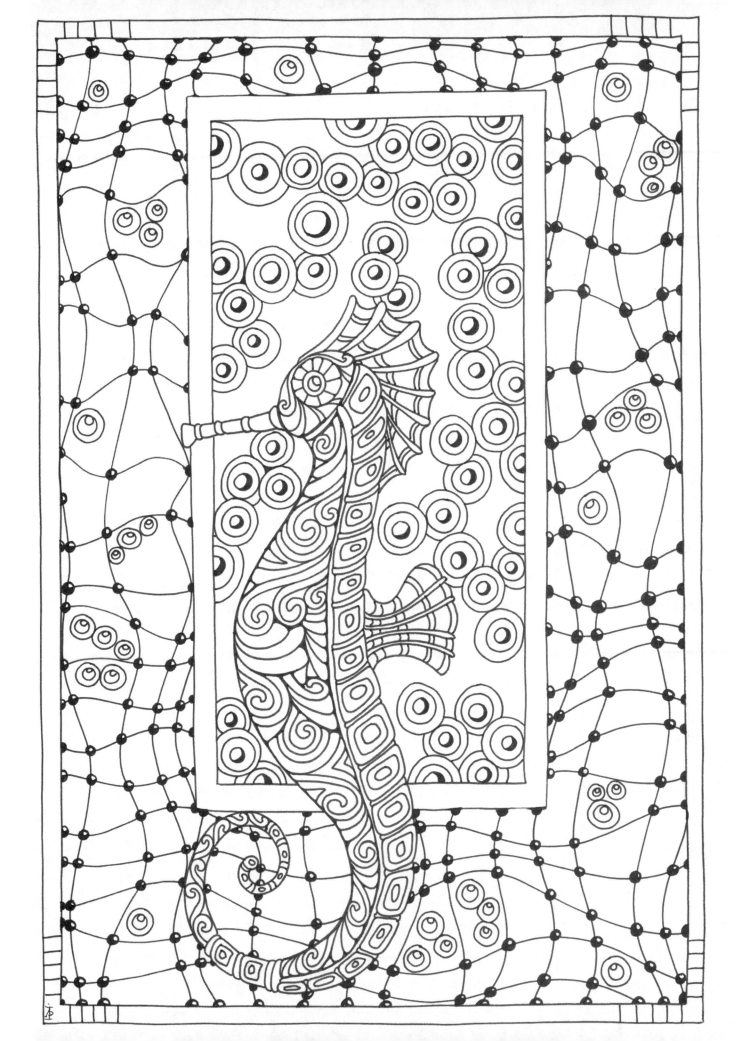

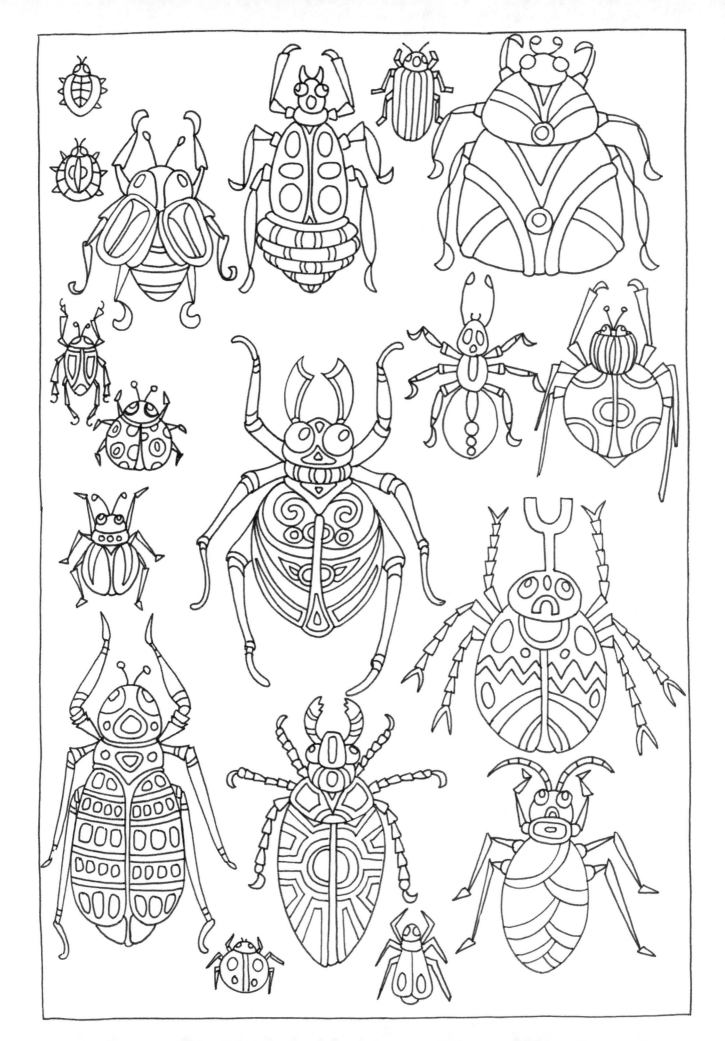

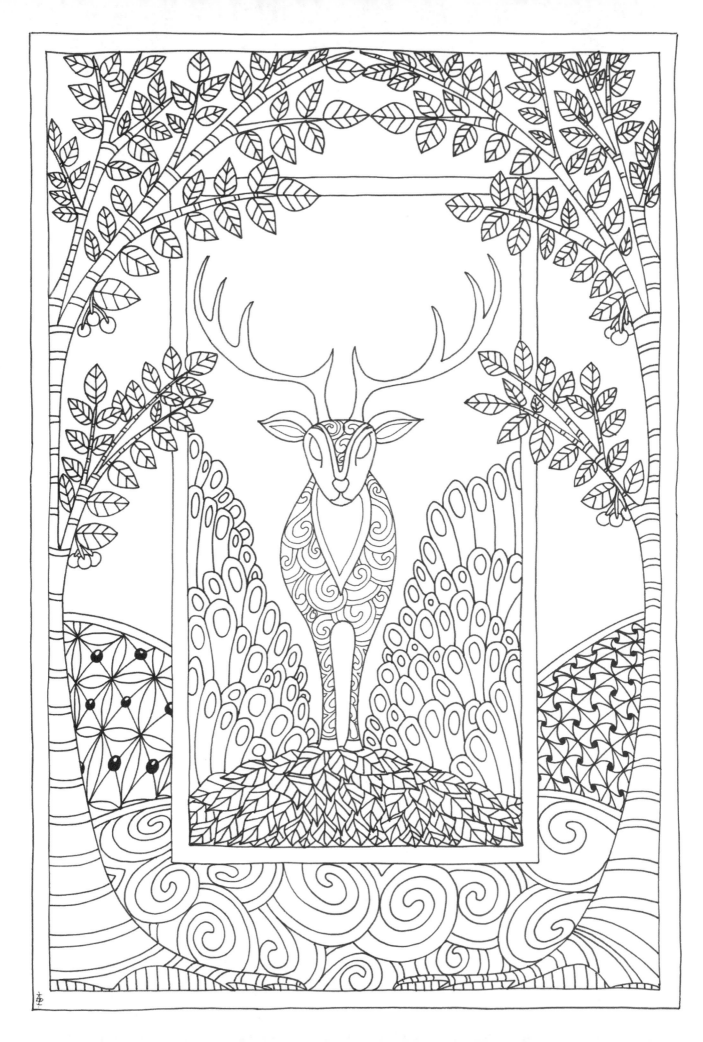

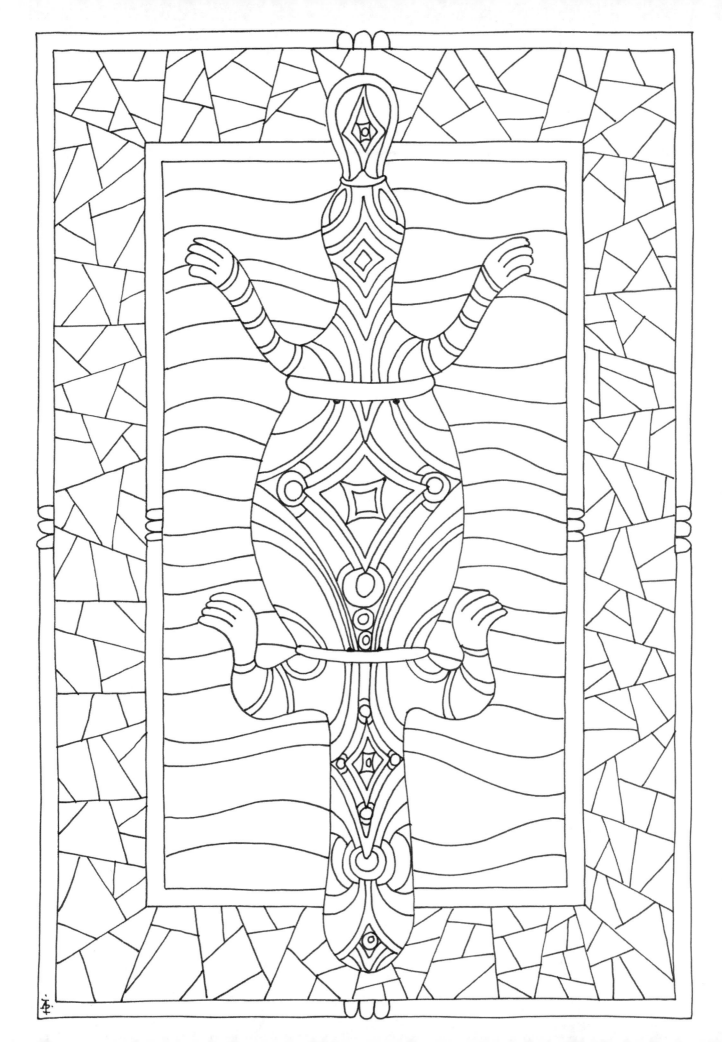

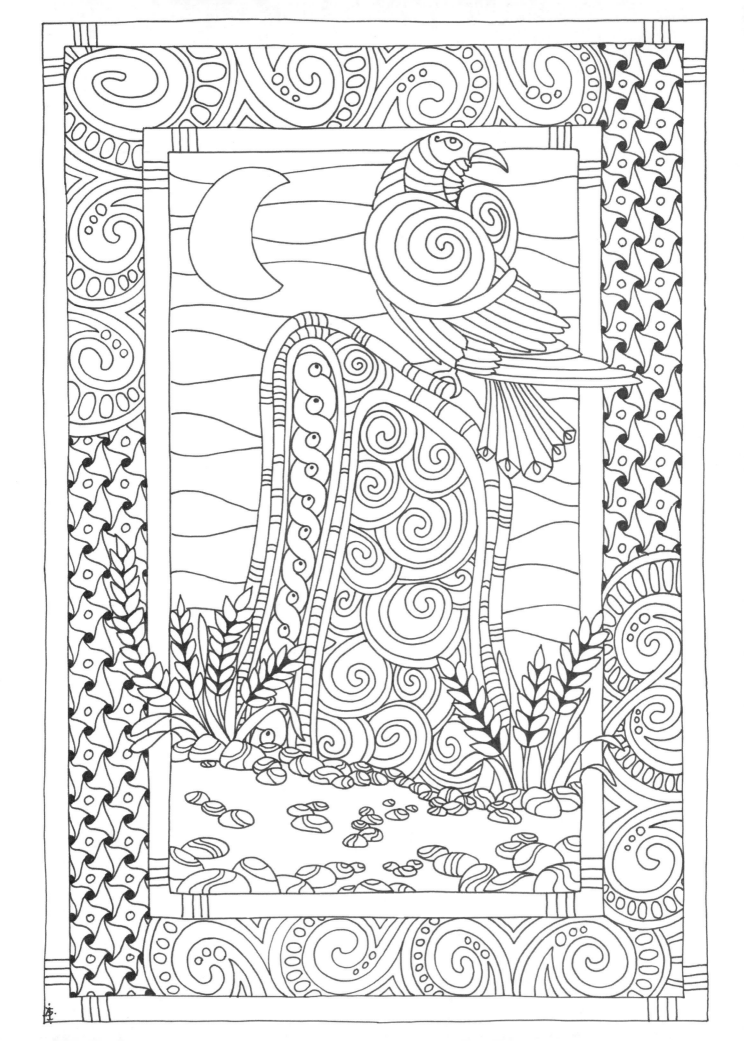

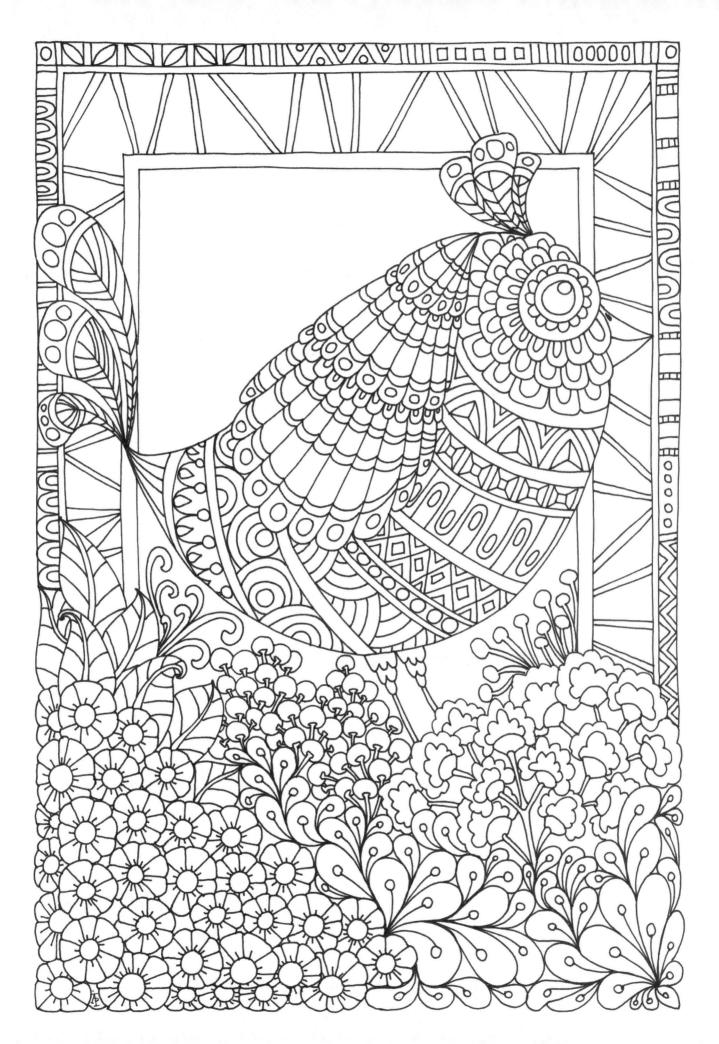

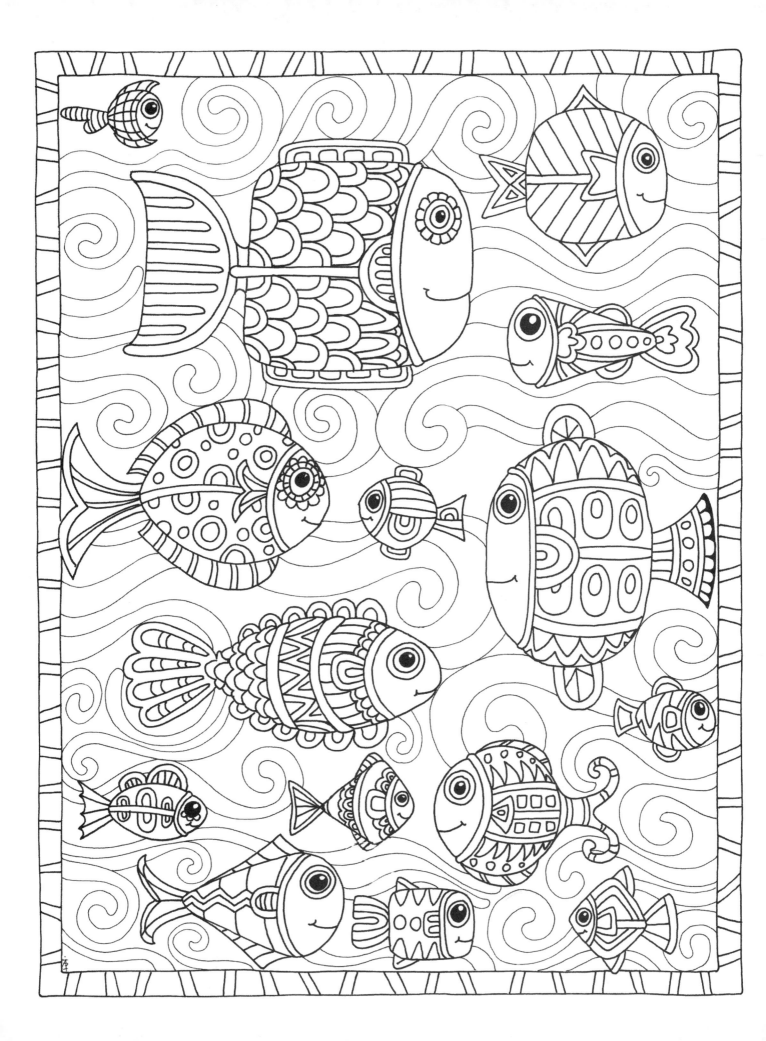

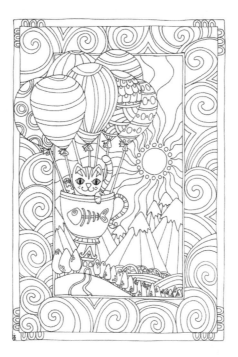

Zen doodling emerged in the early nineties in art therapy, and more recently within adult coloring. With its repetitive patterns and expressive qualities, Zen doodling aids stressed colorists in focus and mindfulness. The form consists of all different types of patterns and motifs—swirling, circular, and geometric sequences woven together and built upon one another—that place colorists in a relaxing, almost dream-like atmosphere.

Animals are believed to have similar anti-stress properties as the Zen philosophy; by watching and playing with animals, it gives our minds a break from the things that are bothering us with the simplistic beauty of animals and nature. Combining these two concepts, bestselling illustrator Angela Porter takes you on a relaxing journey through the wilderness in this breathtaking collection. By combining shapes and doodles of all sizes and forms, she has provided beautiful animal outlines for you to immerse in color and bring to life!

These outlines incorporate Porter's own unique and intuitive style. Her illustrations are drawn completely by hand and often contain imperfections, giving the designs a human aspect that is highly sought after by many colorists. Additionally, her style includes thick, bold lines that flow with ease and tranquility, making them perfect for de-stressing as you color.

☙

Angela Porter is a New York Times bestselling illustrator and a self-taught artist. She finds inspiration in the architecture, archaeology, industrial and scientific heritage, and nature of her surroundings. Much of her intricate work is abstract and whimsical with imaginative elements, rich with flowing lines that create textured and detailed designs. A special-needs science teacher for more than twenty-seven years, Angela relaxes with her art and also by playing the flute and learning to play electric folk harp. She lives in South Wales, Great Britain, with her crazy white cat that has a fondness for a nice warm mug of tea.

Also Available from Skyhorse Publishing

Creative Stress Relieving Adult Coloring Book Series

Art Nouveau: Coloring for Artists

Art Nouveau: Coloring for Everyone

Curious Cats and Kittens: Coloring for Artists

Curious Cats and Kittens: Coloring for Everyone

Mandalas: Coloring for Artists

Mandalas: Coloring for Everyone

Mehndi: Coloring for Artists

Mehndi: Coloring for Everyone

Nirvana: Coloring for Artists

Nirvana: Coloring for Everyone

Paisleys: Coloring for Artists

Paisleys: Coloring for Everyone

Tapestries, Fabrics, and Quilts: Coloring for Artists

Tapestries, Fabrics, and Quilts: Coloring for Everyone

Whimsical Designs: Coloring for Artists

Whimsical Designs: Coloring for Everyone

Whimsical Woodland Creatures: Coloring for Everyone

Zen Patterns and Designs: Coloring for Artists

Zen Patterns and Designs: Coloring for Everyone

New York Times Bestselling Artists' Adult Coloring Book Series

Alberta Hutchinson's Instant Zen Designs: New York Times *Bestselling Artists' Adult Coloring Books*

Alberta Hutchinson's Peace Mandalas: New York Times *Bestselling Artists' Adult Coloring Books*

Marjorie Sarnat's Fanciful Fashions: New York Times *Bestselling Artists' Adult Coloring Books*

Marjorie Sarnat's Pampered Pets: New York Times *Bestselling Artists' Adult Coloring Books*

Marty Noble's Sugar Skulls: New York Times *Bestselling Artists' Adult Coloring Books*

Marty Noble's Peaceful World: New York Times *Bestselling Artists' Adult Coloring Books*

The Peaceful Adult Coloring Book Series

Adult Coloring Book: Be Inspired

Adult Coloring Book: De-Stress

Adult Coloring Book: Keep Calm

Adult Coloring Book: Relax

Portable Coloring for Creative Adults

Calming Patterns: Portable Coloring for Creative Adults

Flying Wonders: Portable Coloring for Creative Adults

Natural Wonders: Portable Coloring for Creative Adults

Sea Life: Portable Coloring for Creative Adults